SURF ~ *A visual exploration of Surfing*
by Steffen Mackert
Edited by Robert Klanten

Translations by Galina Green
Proofreading by Ashley Marc Slapp
Printed by Ingoprint, Barcelona

Published by Die Gestalten Verlag Berlin, 2005
ISBN 3-89955-090-0

Bibliographic information published by Die Deutsche Bibliothek
Die Deutsche Bibliothek lists this publication in the Deutsche Na-
tionalbibliografie; detailed bibliographic data are available in the
Internet at http://dnb.ddb.de.
Bibliografische Information Der Deutschen Bibliothek
Die Deutsche Bibliothek verzeichnet diese Publikation in der
Deutschen Nationalbibliografie; detaillierte bibliografische Daten
sind im Internet über http://dnb.ddb.de abrufbar.

For more information please check: www.die-gestalten.de

A big thank you to anyone, who has supported me in any aspect (u2Su). An even bigger thank you to the following people, foundations and companies in no special order: ELSNER & FLAKE Type Consulting www.elsner-flake.com | FATUM surfboards (Thomas Lange, Gero,HiQ-HH). www.fatumsurfboards. com | BRETT Magazin (Mark Fiebelkorn). www.brettmag.de | SURFRIDER FOUNDATION for making the world more clarified and the oceans cleaner. For a better consciousness of what you're doing. www.surfrider-europe.org | GREENPEACE-MAGAZIN for the marine life illustrations made by Carsten Raffel. www.greenpeace-magazin.de | MUTABOR DESIGN (Johannes Plass) www.mutabor.com | KRISTINA DÜLLMANN www.callmek.com

Maximum respect in any aspect to:

Jens Meyer. Who made some board designs, the cute and beautiful girls in the current-chapter and the IWL-OWH pictogram in the outside chapter. And not to forget the surfmobiles on page 53…

Carsten Raffel. He made the beautiful icons below every page. The StylePolice-Type and the nice sea animals for the greenpeace-magazine. Thanks for your constructive support and your acquaintance. Watch them at: www.unitedstateoftheart.com

And last but not least: Thank you, Nuck Chorris…

That's the motto and the way to go Surfing is still a subculture. It has a spiritual aura that you only get once you've experienced it yourself. Surfing is a sport and a way of life you have to experience to really understand. It's always a journey to the inner self. Of course the commercialisation of surfing has had a negative impact on the TRUE SPIRIT of the sport. But despite that, it has not, and never will lose its soul and spirit, because the magic that envelops you when surfing is far too powerful.

What defines a footballer, a snowboarder or a surfer; what characterises him and how does he define himself other than through the action of surfing? Of course you'll come across superficiality, show, styles and outward appearances that don't add up to who the person actually is, but nowadays that's impossible to define anyway.

Like foam bubbles, identities and appearances dissolve, overlap or separate in order to re-emerge in changed shapes or dimensions. Surfing isn't the same as football, - that much is certain, - and few sports, (or is it just a postmodern phenomenon?) present such a highly illustrative and iconic image to the outside world as 'extreme' sporting activities do.

Appearances change, identities don't, and it is the identity of the surfer that this book is about, without clinging to cliché or prejudice. Stylistic devices are shown, characteristics are illustrated and a summary provided of everything that can be attributed to the surfer. From the shorts down to the car. If you are expecting to see the hottest surf photos or pixels, you've come to the wrong address. This book is intended to provide you with a small insight and a basis for what you still need to learn, but which should be experienced first hand if you want to come close to what it means to be a "surfer".

As author and illustrator I want to point out, especially where the didactic aspect of this book is concerned, that I am neither a professional surfer, nor am I a surf instructor: I can merely point out certain graphic features and characteristic elements as I see them as a graphic artist. And I can only pass on what's worth learning in terms of the small tips and knacks I've picked up during my second or third surfing life, and try to do it in an easily comprehensible, illustrative and pleasing way.

Communication is something that works best without words, and the world in which we live today couldn't be more complex and complicated than it is. At the same time, surfing is something that can only be peripherally explained and described. It is far too complex and much too internalised to approach in

any other way. So I've tried to address and solve the problem of explaining content by taking a different route. At first glance, it will appear perhaps more trivial as well as more complicated than it should. That's because an important element on which this book is based is metaphor. Primary matters are explained and illustrated through secondary images and metaphors. The 'in your face' way would be too banal or perhaps too complicated, in the same way that a particularly effective icon or pictogram is. That, though, wasn't the challenge or the mission I had in producing this book. It should, in the first instance, be fun, and in this way convey the information that will smooth your path to the world of surfing.

In this book you'll find tips to make things easier for you. How to take the unnecessary sweat and tears out of your first day's surfing, for example. They're small details that make up the whole. In addition, you will be putting yourself into situations that could, without you having imagined it at breakfast, cost you your life. Water, weather, waves and currents have to be experienced first hand. It's only pure theory, with absence of fear or danger, from the safety of the shore. But as soon as you venture out into the big blue, you have to be aware of the risks. That's why a basic understanding of meteorology is just as important as the way you handle your equipment and your own body.

It's meant to scratch the surface and, in an amusing way, open an inner door just a little, for those who have enjoyed and found interesting the things to be found in the following pages of this book. This book isn't really trying to teach the subject comprehensively; surfing is too complex a sport for that. On the one hand it is of course a sport, but on the other, it also represents a virtual spiritual world, which, as I have already mentioned, you can only really experience by living it yourself. What I am offering is a starting point from which to take on tasks at hand without becoming entangled in theoretical discourses. I have to know what it's about, why and how certain things function in the way they do. If that spurs my interest, then it lies in the nature of the curious individual to carry out further research and to collect more information and experience.

Step into a new world ~ Fluid Life.

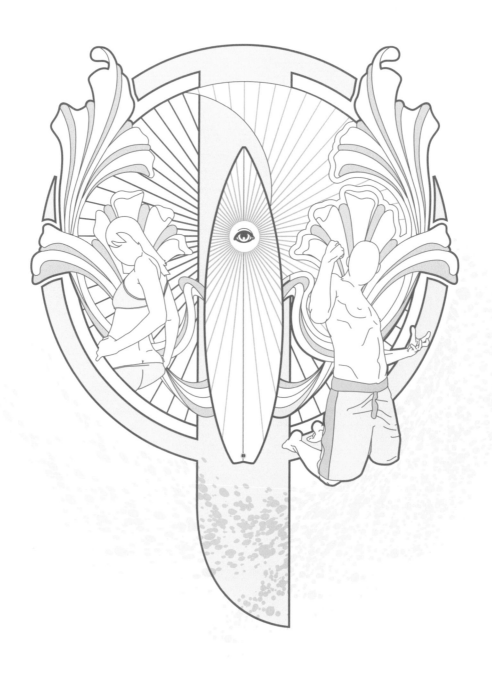

SURF

a visual exploration of surfing

CONTENTS

 01

07

SiXFOOTSiX

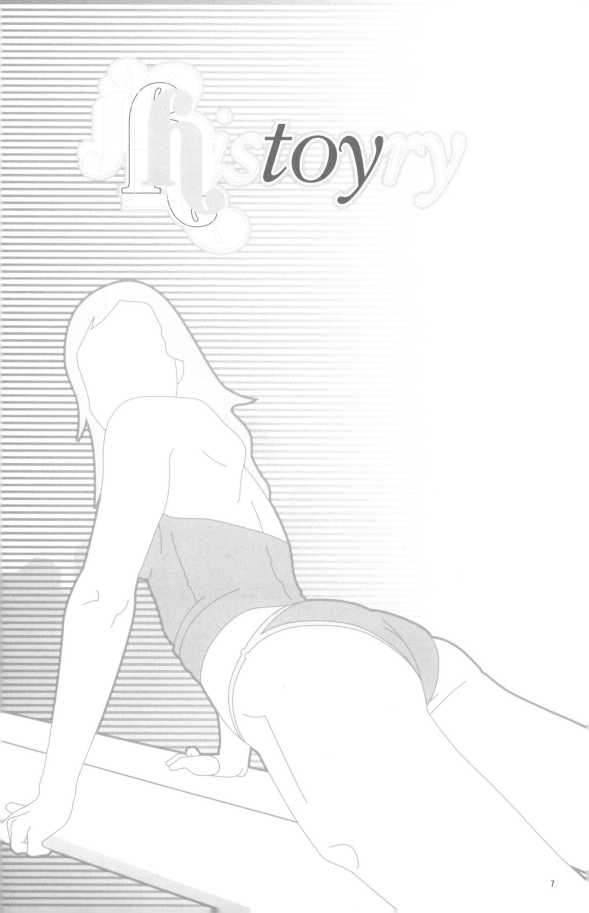

REVOLUTION WITHIN EVOLUTION

THE STORY OF SURFING, LIKE ANY STORY, TAKES US THROUGH HIGHS AND LOWS, WHICH IS WHAT TURNS EVENTS INTO HISTORY AND NOT JUST PART OF THE PAST. LIKE MOST OTHER CULTURES, THE WHITE MAN HAS ALMOST DESTROYED THIS ONE, AND MADE A SUBCULTURE OUT OF A CULTURE.

➡ THROUGH THICK AND THIN

Once upon a time, many years ago, on a tiny, far-off island in the middle of the vast Pacific Ocean. The legend tells us that a small group of Polynesians, in small canoes and twin-hulled catamarans left their homeland to set off on a journey, not knowing their final destination. They rowed northward without knowing where their voyage would take them. Just when they thought of giving up and turning homeward, the legend goes, a large white shark appeared and led them onward.

They navigated by the stars, orientated themselves by the winds and cloud formations and by patterns formed by a combination of wind, land and currents on the water's surface. This is how they discovered, one thousand sea miles north of the Equator, signs of land. After many weeks at sea, they touched land on the southern cape of the Hawaiian archipelego, the most remote group of islands in the world. Those Polynesian roots are even now deeply embedded in the Hawaiian culture, but have, over the years, developed into an independent culture and civilisation. There is ample evidence that surfing was widespread in the Pacific region long before the first contact with Europeans took place. Hawaiians had a deep connection to surfing and to the powerful energies of the ocean that surrounded them. They had almost as many names for the different kinds of wave as Eskimos do for snow.
As early as the second half of the 18th century, Hawaiians were masters of surfing, combined with a deep, spiritual consciousness of water and nature. In the beginning surfing, or riding the waves on boards, was the preserve of the chiefs and tribal leaders. Of course

the "common man" surfed as well, but as a ceremony, it was the preserve of the kings. This paradisical situation was suddenly transformed with the first landing of the white man on Hawaii in 1778 under the leadership of Captain James Cook. Metal, guns, cannons, uniforms, alcohol, sexually-transmitted diseases and a strange new religion led to the cultural implosion of the indigenous Hawaiian civilisation. After the arrival of the white man, an estimated 400,000 people fell victim to European bacterial and viral diseases. By 1890 only around 30,000 to 40,000 indigenous people were still left alive.

With the destruction of the old civilisation, the original surfing culture disappeared too. In the mid 19th century, the combination of Christian evangelism, an increasingly organized and commercialised economy, as well as the decimation of the indigenous Hawaiian population, surfing became an ever rarer pleasure.
Only a few enclaves on the island kept the tradition alive and ensured that it survived during the 19th century. At the turn of the century the custom was reborn with the founding of an official surfing organisation, the "OUTRIGGER CANOE AND SURFING CLUB". The writer Jack London discovered the passion of the island dwellers and wrote about it in newspaper articles and books, thus fuelling an increase in tourism, attracted by the wave-surfing inhabitants, who were a special attraction. On the beach of Waikiki,

the focus of a new surfing culture was established. Beach huts were built and whole stretches of beach developed. Three years later a group of almost exclusively Hawaiians founded the "HUI-NALU" Surf Club, while the other surf club consisted mainly of "Haoles" (foreigners).

The two surf clubs competed with each other in countless surfing competitions. By 1915 the Outrigger Surf Club had around 1200 members with hundreds on the waiting list and a stretch of beach almost a mile long, with huts and lockers for the boards. Surfing had become fashionable.

An Hawaiian of Irish descent, George Freeth, was one of the best surfers around, and renowned through Jack London's article, his 'extraordinary' skills were soon being talked about all along America's coasts.

Around this time a real beach boom was taking place in California, and Freeth was invited to demonstrate his skills to the masses, and entranced them with his riding of California's waves. That's how a new interest in this sport arose, and the foundation stone was laid for a new SUB-CULTURE. The Hawaiian, Duke Kahanamoku, was known as the "father" of modern surfing, and was renowned as an outstanding athlete, swimmer and oarsman.

In 1912, with the help of his size 48 "Luau feet" and his famous "Kahanamoku-Kick", he won a Gold Medal at the Stockholm Olympic Games in the 100 metres freestyle. Wherever he went, his surfboard was at his side and he demonstrated his skills on the board all along the coasts of America and the rest of the world. He knew how to thrill people, and in so doing created publicity for the sport. Hollywood soon took notice of the well-built and clever Duke and he appeared in a total of seven Hollywood productions, in roles as diverse as an Indian chief and an Arabian prince.

In 1930 Tom Blake from Wisconsin patented the first hollow surfboard, (Cigar Board) weighing less than 50kg, thus kick-starting a revolution in experimentation with shape and design. Tom Blake's Cigar Board was also the first industrially produced surfboard. In the Golden Twenties surfing culture spread along the coast like wildfire and the number of "Haoles" quickly grew.

Even after the economic depression of the Thirties, when public activities were virtually paralysed, young kids still headed to the beaches, as surfing was something you could indulge in without having to spend money.

At that time a so-called "Neo-polynesian" era began, in which the young surfers began to understand and respect the roots of the sport. They went camping along the beach in hula skirts, played ukelele and made pilgrimages to Hawaii. One surfing hotspot after another was established and Hawaii became the surfing Mecca, it still remains today. The equipment became lighter and better. The so-called "hot dog" board was developed, with its sharp tapering tail, and moulded on the underside in a V-form. This allowed the board to turn in the wave and surf on the curl, almost parallel to the running wave without the tail breaking out. This board finally made it possible to surf larger waves, and a new era of surfing began. Heavy wooden boards were replaced by fibreglass plywood laminates and fitted on to the tail were what we call fins today. The nose was curved upward and "Hot-Dogging" characterised the style of the fifties and sixties, after the Second World War had imposed a short intermission on surfing. Ever larger waves were attempted, but unfortunately many didn't survive these.

The fifties and sixties were also the period in which the first surfing films and surf music came out, (such as The Beach Boys or Dick Dale and his Del-Tones) They brought surfing and the culture surrounding it, the lifestyle and the mythology, into the media and so to a mass audience. I have to mention "THE ENDLESS SUMMER", by Bruce Browne, as one of the best and funniest films on surfing there is, and which established the Malibu Longboard in its still prevalent form. The surf boom continued into the late sixties and seventies and in addition to the music and films, the first magazines appeared, creating simultaneously an enormous and important market for surf photography. The existence of these magazines changed everything. The magazine medium created heroes, disseminated the stories worldwide and fanned the enthusiasm for surfing.

Advertising discovered surfing and design took over the surfer image. Phil Edwards, in the late sixties probably the best surfer in the world, was the first professional to get 23 dollars for every "Hobi" surfboard sold. Thanks to the films, the magazines and music, surfers all over the world enjoyed an extraordinary popularity. Those surfers paid by the industry earned enough money to live on. Nevertheless, that is hardly comparable to the present day. Surfing has become a competitive sport.

Although that didn't quite fit the image of a subculture and damaged the true spirit of the sport, a real competitive industry arose, organised and with rules. At the end of the seventies, the short board revolution arrived, triggered by the Australian surf culture that had enjoyed a parallel development. Suddenly, with the new, very short (6 to 7 feet) fibreglass boards, new figures, techniques and styles were suddenly possible. It was possible to surf directly in the wave wall, and execute proper manoeuvres. The longboard was relegated to dinosaur status. The most important initiators of the shortboard revolution were George Greenough and Bob McTavish, who took the design of surfboards to new dimensions. In 1968 surfing underwent the most enormous cultural and conceptional change of its entire history. Everyone threw away their 9-10 feet long surfboards and swapped them for small, 6-8 feet short boards.

And the saga continuous

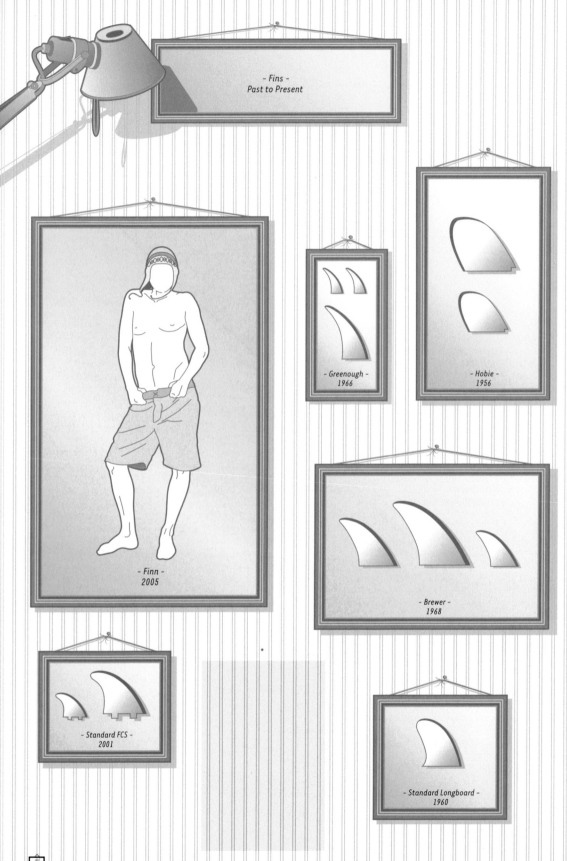

- Fins -
Past to Present

- Greenough -
1966

- Hobie -
1956

- Finn -
2005

- Brewer -
1968

- Standard FCS -
2001

- Standard Longboard -
1960

30

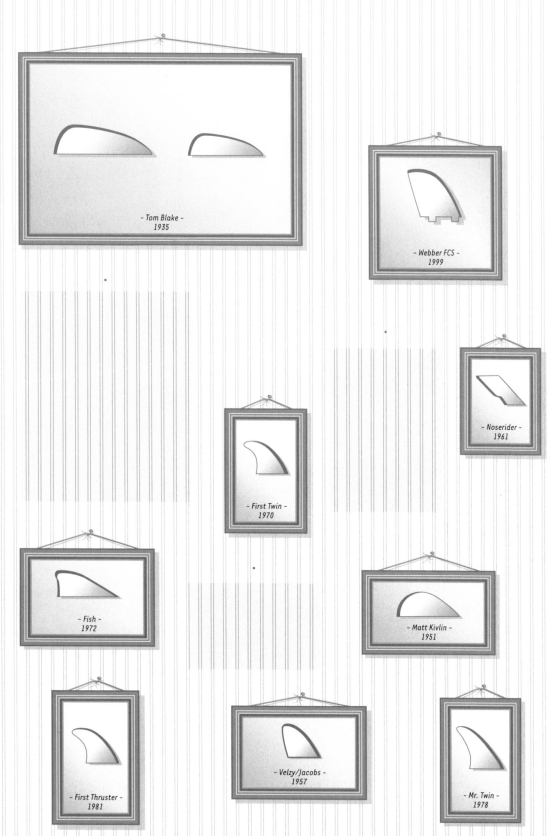

- Tom Blake -
1935

- Webber FCS -
1999

- Noserider -
1961

- First Twin -
1970

- Fish -
1972

- Matt Kivlin -
1951

- First Thruster -
1981

- Velzy/Jacobs -
1957

- Mr. Twin -
1978

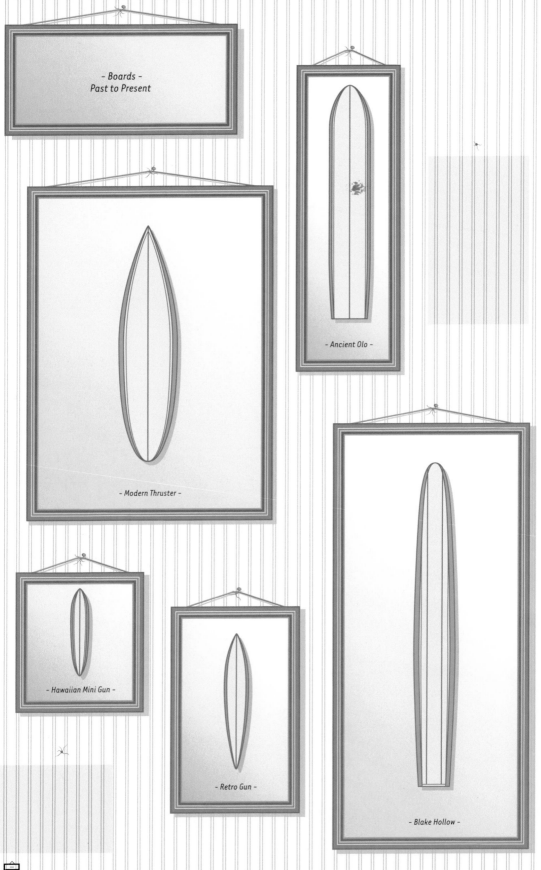

- Boards -
Past to Present

- Ancient Olo -

- Modern Thruster -

- Hawaiian Mini Gun -

- Retro Gun -

- Blake Hollow -

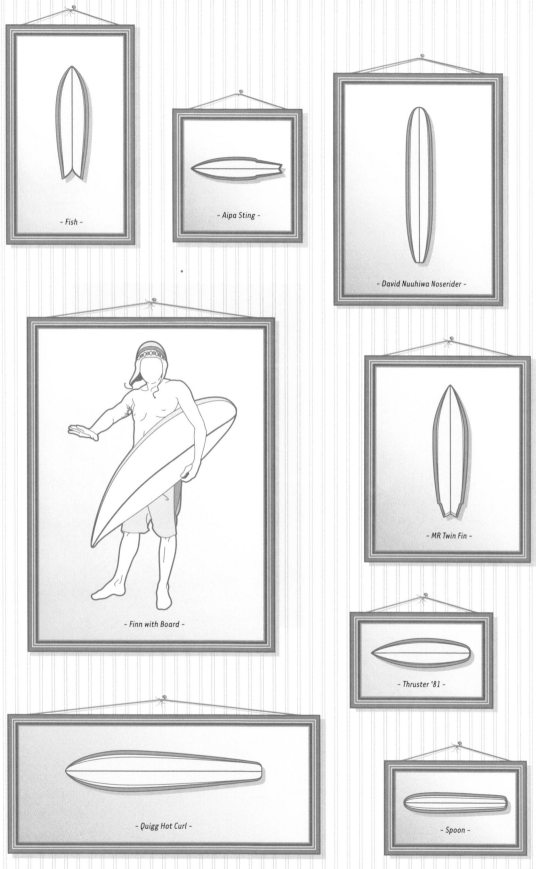

- Fish -

- Aipa Sting -

- David Nuuhiwa Noserider -

- Finn with Board -

- MR Twin Fin -

- Thruster '81 -

- Quigg Hot Curl -

- Spoon -

13

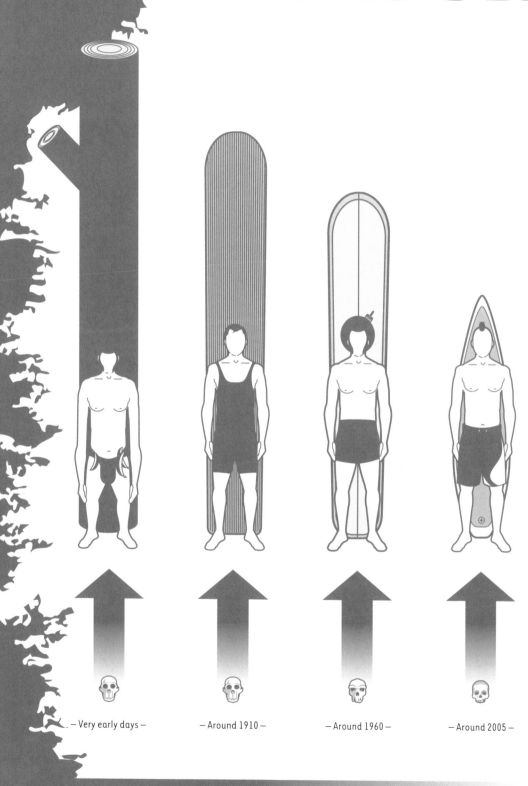

— Very early days — — Around 1910 — — Around 1960 — — Around 2005 —

TRUE TILL DEATH

FROM THE INDIGENOUS HAWAIIANS TO A MODUS VIVENDI

The image cultivated by the surfing industry of health and clean living started to crumble in the face of long-haired, joint-smoking dudes with bead necklaces. A door to the spiritual world of surfing was thrust open and surfers experienced a renewed feeling of belonging to their own subculture. Flower power hit the beaches.

With the shortboard, the music and newly acquired energies, everything changed. Surfing would never be the same again. But the revolution was over as fast as it had begun. After the flower power era in the seventies a more conservative, introverted surf movement emerged, in which surfing communities became divided due to the increasing number of competitions.

Many took part in the competitions and earned good money, the others, often shortboard pioneers, like Mickey Dora, who represented the new style rejected competitions. They did so, because they still judged things by the old rules, and because competitive sports weren't commensurate with the lifestyle and ethics of the "real" surfer. Most people surf to feel at one with nature and reject a materialistic lifestyle, preferring to take a more natural, existential path in life.

💀 ALOHA: literally it means: "alo" experience and "ha" breath of life, in general, and in the modern sense it is used to mean, "hello, see you later, love and friendship"... HAOLE: the arrival of the alien (the white man) and the handshake as a greeting ritual brought us the word "ha' ole", which means roughly: without the breath of life, a foreigner, white man. HE'E NALU: surfing, surfer HE 'O, LA KA MEA HAWAWA I KA HE'E NALU: the inexperienced surfer falls KAHA NALU, HE'E UMAUMA: Body surfing KAHUNA: priests; a Kahuna prays for rain, a rich harvest or relief from suffering and illness. At the same time he uses the strength of his prayer for sorcery, sending death threats or casting nasty spells and calls up the spirits and predicts the weather KAI EMI, NALU MIK: a receding wave KAI PI'I, NALU PU: high wave KAI PO'I, NALU HA'I: a breaking wave MALU HA'I LALA: a diagonally-breaking wave NALU: the surf, ocean, wave NALUNALU: rough seas PAE: to take a wave PAE I KA NALU: to ride a wave to the beach PAPA-HE-NALU: surfboard WAHINE: woman, female surfer.

CLEARLY, SURFING AS A SPORT IS INCREASINGLY GAINING ATTENTION AMONG THOSE WHO ARE LESS INTERESTED IN THE WORLD OF SURFING, BUT MORE IN THE BUSINESS SIDE, WHERE ADVERTISING IS THE KEY TO SUCCESS. TO BE HONEST, I WOULDN'T HAVE A PROBLEM WINNING 7000 DOLLARS FOR COMING EIGHTH IN A COMMERICIALLY-ORGANISED, WELL SPONSORED SURF COMPETITION. THAT'S BETTER THAN DIGGING TRENCHES OR WORKING AS A STREET VENDOR ANY DAY."
Bill Hamilton, Surfer, 1971.

Once a leash was added to the equipment in 1971, the surfer's safety also increased. The same can be said for the invention of neoprene suits by Jack O'Neill. This meant that the sport became increasingly technical, the manoeuvres more complicated and at the same time surfers could stay longer and more safely in the water.

New surfing spots were opened up and the whole movement was taken to a higher level. The nomadic lifestyle was rediscovered after "The Endless Summer" alongside a growth in the number of surf competitions. The surf nation was divided: the so-called competitive surfers and the soul surfers, searching the planet for the perfect wave. From the Easter Islands to Indonesia and Tasmania. The surfers were discovering their own galaxy.
But it was clear to everyone that for that to happen, a broad consumer market would have to be catered for. In the eighties, the surfing industry had been able to corner a large chunk of the leisure and sportswear market and ensure good profits. But as soon as a sporting activity, a subculture like surfing, windsurfing, snow-

boarding or skateboarding, is confronted with marketing structures, it automatically becomes subject to fashion trends.

Until today, wave riding has undergone continuous development. Style, perfection and techniques have reached levels that no one would've believed twenty years ago. Just as 50 years ago, no one would have dreamt that it would be possible to surf a wave higher than 60 feet.
Now that surfing, firmly anchored in a global industry, is at the mercy of all fluctuations and trends, it's popularity will ebb and flow. This is probably a good way to ensure its survival as a subculture, while nevertheless enabling it to present a professional profile.

The fact that big wave tow-in surfing has just made headlines in the media, means surfing is, for a short time, in the spotlight again. Until those who create the clothing market get bored and start re-styling and looking for a new look. "Perhaps give it a bit more of a golf touch..." they will say. But a true surfer will never trade-in his identity. He will survive the trends and fashions, staying true to that identity.

Aloha.

ADAPTATION

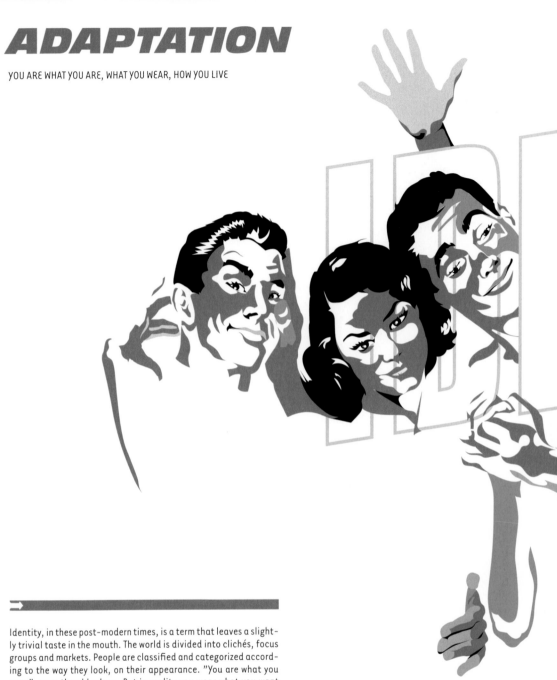

Identity, in these post-modern times, is a term that leaves a slightly trivial taste in the mouth. The world is divided into clichés, focus groups and markets. People are classified and categorized according to the way they look, on their appearance. "You are what you wear", goes the old adage. But in reality you wear what you want to be. Whether it's hip-hop or hippy, the uniform of an originally impervious subculture, whatever it may be, it is readily available for cash anywhere.

An insider knows what to look for, but the frontiers become blurred; tattoos and piercings have become a fashion statement, confusing things even more. Surfers have always distanced themselves somewhat from the ordinary public, on the basis of their lifestyle and cultural background. If you want to be a surfer then there's no way of getting around the need for a proper grounding in your metiér. Knowledge about the history of surfing, about the present day and about people who have influenced the sport in the last few decades is important.

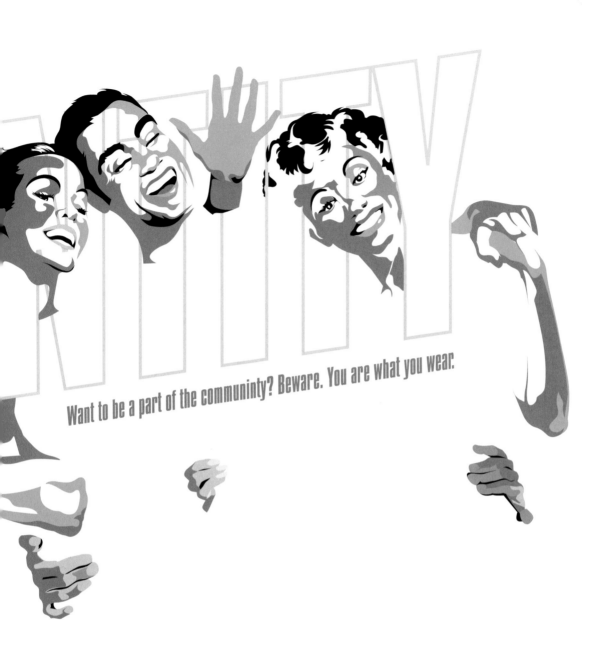

Want to be a part of the communinty? Beware. You are what you wear.

YOUR PERSONAL BOARDING CARD

THE RIGHT BOARD FOR THE RIGHT TIME
— AN EXTENSION OF YOUR BEING — CHOOSE ONE

The surfboard is surely one of those precious things worth protecting and revering. No one would ever forget their first surfboard, if they haven't kept it safe in the cellar or in their trophy cupboard. For beginners, it's hard nowadays to resist buying a super cool shortboard straight off. It's impressive on the beach and provides good shade, but it's no good at all for learning the basics in the water.

Because standards are continually improving and a commercial market has developed, the differences are hardly visible for a beginner when it comes to board design. There are fishboards, thrusters, Malibus, eggs, longboards, guns and strapboards. Every board is specifically designed for a different purpose. These differences have further relevance within each board category when it comes to size, width, weight and flexibility, as well as shape and fins.

To bring a bit of light into the darkness, the basic characteristics of each board will be explained and illustrated on the following pages. One thing, however, hasn't changed over the many decades. 95% of all boards are still shaped by hand and only occasionally do mass produced boards turn up, to be sold at discount prices, mainly for the beginner's market. You should always try to talk to someone, preferably the shaper about which board is right for you. Once you improve, there's no way to avoid having a board made specifically for your needs and physical specifications. For beginners one thing is certain: you will need three times as long to learn to surf with a shortboard than you would with a Malibu or an egg (longboard).

MEN AT WORK

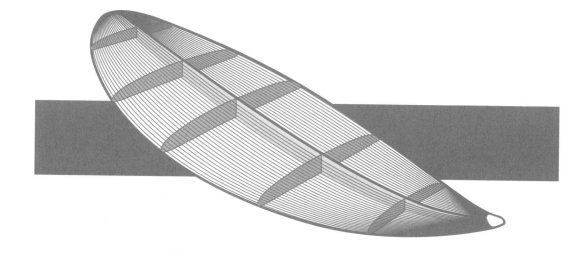

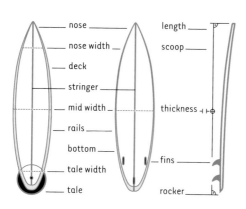

nose
nose width
deck
stringer
mid width
rails
bottom
tale width
tale

length
scoop
thickness
fins
rocker

PLUG

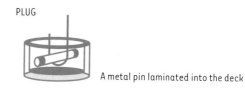

A metal pin laminated into the deck

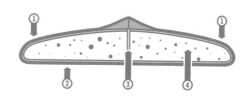

FROM ABSTRACT TO REALITY

You only find out how much work is involved in making a surfboard when you try to make one yourself. The question of shape isn't such a big deal, it's more the finer details that define a good board and influence its movement in the water and its trim. Basically the theory is quite easy to understand, but as I said, the devil is in the finer details. To start with, you decide on a basic form, you make templates and take measurements, then cut, plane and file the basic form out of a block of polystyrene. Once you've done that, you've laid down the basic dimensions of your board, and how much scoop and rocker your board will have. Scoop is the curve of the board from the middle to the nose. Rocker is the total curvature of the hull, from tail to the nose. After the basics are finished, mark the spot where you want to place the fins and where you want to fix your cup for the leash. Everything has to be exact and perfectly symmetrical. Then the finer detailed work begins. After many hours of sanding you are close to the final form. Then several layers of fibreglass matting are laminated onto the board using epoxy resin. Usually 3-5 coats are needed on the deck, because it takes the main wear and load, then 2-3 coats on the underside. Don't forget each side has to dry for at least 24 hours to become really hard before you can turn the board. At the same time, the fin inserts are fixed with laminate in the pre-countersunk holes. Afterwards, when both sides have hardened, the process of sanding and polishing takes place. Then the board is ready. Obviously I've oversimplified the process and there's a lot more to be said on this topic. Interested? Then you should buy yourself a book specifically about shaping.

DECK:

1. Laminate – largely made up of epoxy resin with 3-5 layers of fibreglass. 2. HULL: In order to save weight and because it takes less wear and tear, it requires only 2-3 layers of fibreglass. 3. STRINGER: Adds stability and support and is made of a light type of wood. 4. CORE: Consists mainly of Clark foam, Polystyrene or Styrofoam-type foam.

FCS FIN-SYSTEM

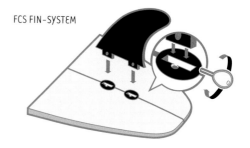

Through the years there have been many different types of fin systems. Times have changed and so have the fins. The main system used today is the replaceable FCS (FIN CONTROL SYSTEM). This makes riding less problematic and replacing damaged fins is no problem at all. But don't lose your fins.

TAIL HUNTER

®DESERT EAGLE -.357 MAGNUM PISTOL
SHIVAMATOR MILITARY INDUSTRIES LTD (I.M.I)

SHORT TAIL STORIES

1. SQUASH TAIL/ROUNDED SQUARE
The most popular and the best all-round tail shape. The board possesses good drive and good manoeuvrability. Suitable for almost all wave conditions.

2. CHOP SQUASH TAIL
This special tail shape is not meant for beginners. The surf-characteristics are somewhere between a round square and a swallow tail. The sharp edges mean that you can't get a way with as many mistakes, and the board is much more sensitive.

3. ROUND PIN TAIL
A rounder tail than the squash tail, which affects its turn-ability. Hard turns are not as easy; the board is a lot rounder in its glide effect. Recommended for soft round waves and for a smooth ride.

4. PIN TAIL
Gives the board good drive and support, especially in big waves. These tails are usually used in GUN boards. Also in big wave planks for high speeds.

5. SWALLOW TAIL/FISH
Predestined for short freestyle boards. The tail guarantees best manoeuvrability and good speeds, especially in small waves.

6. SINGLE WING /SWALLOW TAIL
The effect of finer details at the tail are not discernable for the beginner but for professionals they are and become essential. Additional edges in the tail region can help you obtain more flexibility out of the ride and the board can make a curve that bit faster and harder without a perceptible reduction in speed.

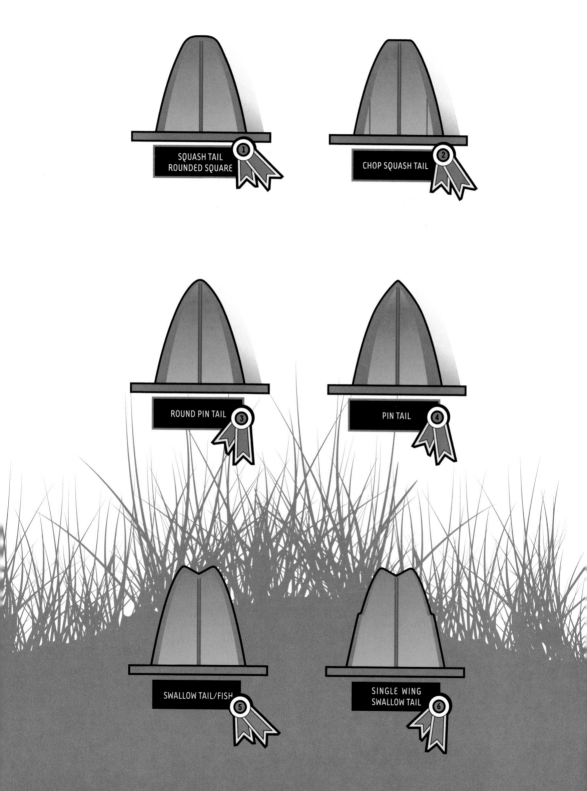

SQUASH TAIL
ROUNDED SQUARE ①

CHOP SQUASH TAIL ②

ROUND PIN TAIL ③

PIN TAIL ④

SWALLOW TAIL/FISH ⑤

SINGLE WING
SWALLOW TAIL ⑥

RAILSHOW

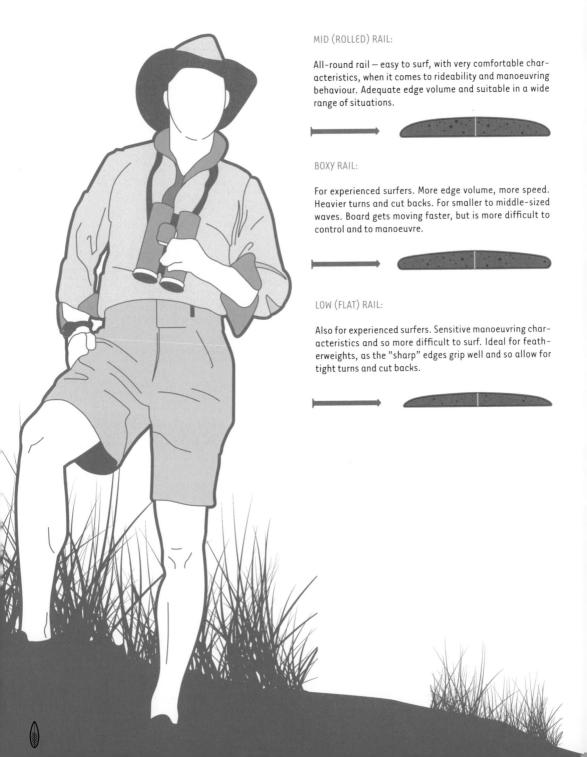

MID (ROLLED) RAIL:

All-round rail — easy to surf, with very comfortable characteristics, when it comes to rideability and manoeuvring behaviour. Adequate edge volume and suitable in a wide range of situations.

BOXY RAIL:

For experienced surfers. More edge volume, more speed. Heavier turns and cut backs. For smaller to middle-sized waves. Board gets moving faster, but is more difficult to control and to manoeuvre.

LOW (FLAT) RAIL:

Also for experienced surfers. Sensitive manoeuvring characteristics and so more difficult to surf. Ideal for featherweights, as the "sharp" edges grip well and so allow for tight turns and cut backs.

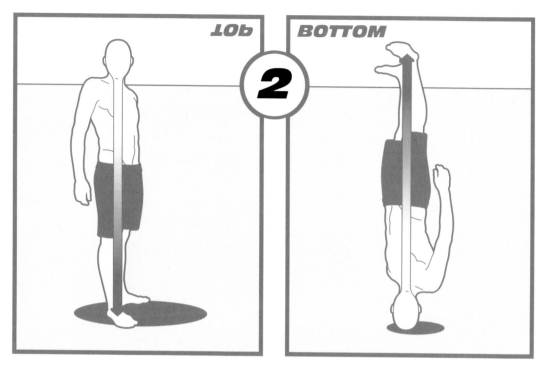

YOU CAN USUALLY DIFFERENTIATE BETWEEN FOUR BASIC BOTTOM SHAPES. DEPENDING ON WHERE THE BOARDS ARE USED, DIFFERENT SHAPES ARE REQUIRED. BASICALLY IT'S THE SAME AS WITH MEN'S AND WOMEN'S BUMS. YOU CAN'T TELL IF THEY'RE GOOD OR NOT UNTIL THEY START MOVING.

FLAT BOTTOM

CONTOURED SHAPE. SIMPLE HANDLING. LETS YOU GET AWAY WITH SMALLER MISTAKES. TOP SPEED IN ALL SITUATIONS.

SINGLE

GOOD SPEED. STRESSED ON THE EDGES. FOR CLEAN HIGH WAVES. NOT FOR CHOPPY WATERS.

DOUBLE

SMOOTHER THAN A SINGLE CONCAVE. ALSO LETS YOU GET AWAY WITH MISTAKES.

VEE

FOR STEEP WAVES. THE "V" COUNTERS THE TRANSVERSE FORCES AND GIVES THE BOARD A GOOD, STABLE STEER.

SHORTBOARD

THRUSTER

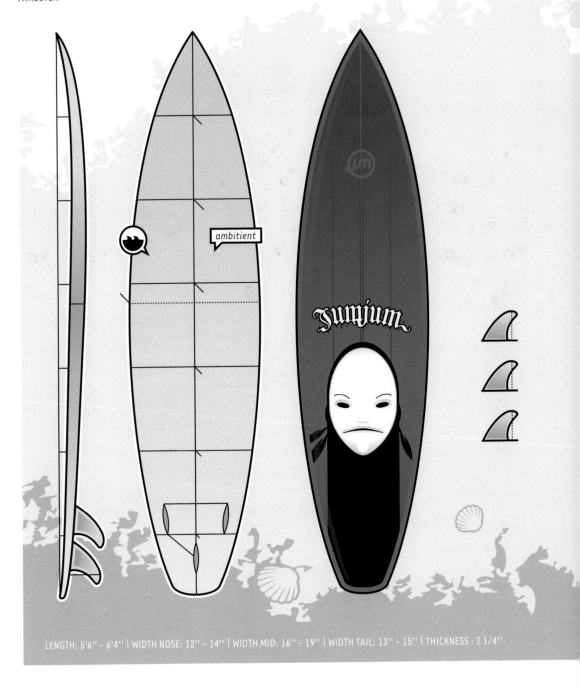

LENGTH: 5'6'' - 6'4'' | WIDTH NOSE: 12'' - 14'' | WIDTH MID: 16'' - 19'' | WIDTH TAIL: 13'' - 15'' | THICKNESS : 2 1/4''

SHORTBOARD THRUSTER

A good board for advanced surfers who have got the basics under their belt. These boards are made for speed and radical techniques and turns. Beginners should refrain from using this shape, as it's quite hard to catch a wave with this kind of board. They have a small volume and really demand skill from the surfer to get up a decent speed.
In my opinion they are not ideal on the Baltic coast because the waves there don't have enough power. I've never seen anyone with this kind of shape really ripping a wave there. The North Sea, with its stronger waves, enables you to surf decently with this board.

LONGBOARD

CRUIZER

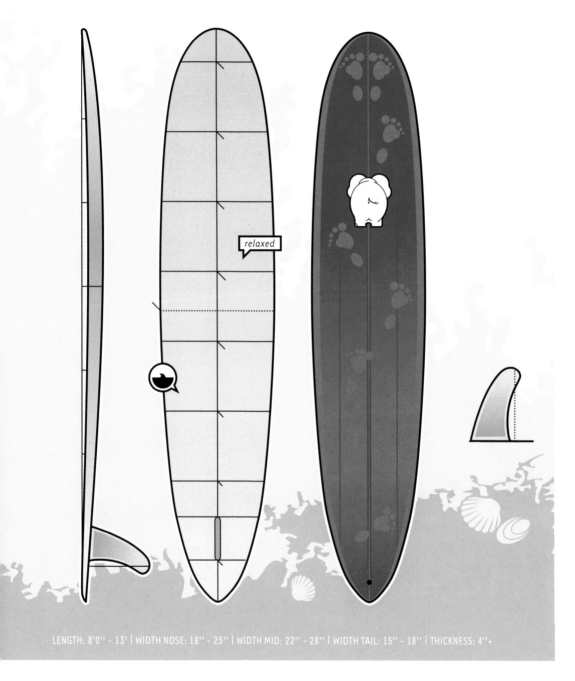

LENGTH: 8'0'' – 13' | WIDTH NOSE: 18'' – 25'' | WIDTH MID: 22'' – 28'' | WIDTH TAIL: 15'' – 18'' | THICKNESS: 4''+

LONGBOARD CRUIZER

LONGBOARDs are the perfect boards for the North Sea and Baltic coasts, because most of the waves are small and don't have much power. But longboards can also be ridden on large waves. The only problem is, how to get through the white water rollers with such a large and bulky board. Longboards aren't as manoeuvrable and are more sluggish than shortboards. But they give a smoother ride and allow you to do hang fives, drop-knee turns, cross-stepping and, these days, they also offer you the possibility of doing shortboard manoeuvres in waves that you wouldn't have dreamt of before.

MALIBU

LONGBOARD

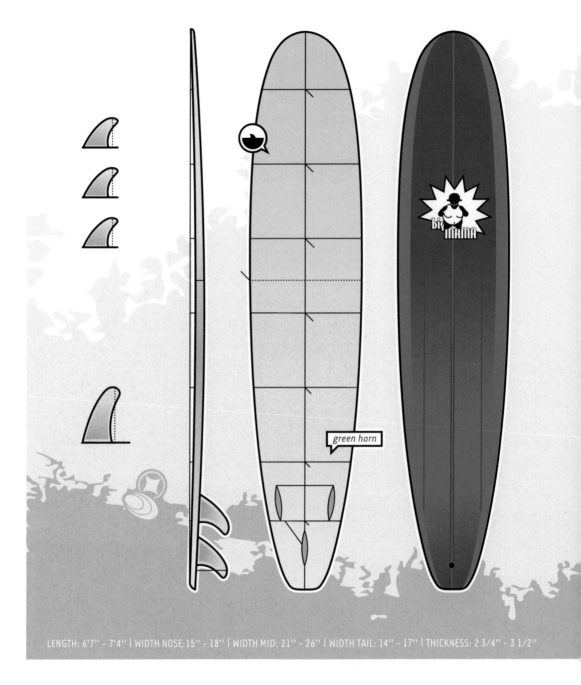

green horn

LENGTH: 6'7'' - 7'4'' | WIDTH NOSE:15'' - 18'' | WIDTH MID: 21'' - 26'' | WIDTH TAIL: 14'' - 17'' | THICKNESS: 2 3/4'' - 3 1/2''

MALIBU LONGBOARD

The MALIBU is a close relative of the fun board. It's intended for similar usage, but is more like a longboard in its riding character-istics and in its shape. Its large nose and, in comparison with others, quite narrow tail, can mean a lot of fun even in small waves. Its narrow tail allows easy turns and even enables you to make shortboard-type turns. It's an ideal interim board for the Atlantic coast on poor days and is really easy to handle and can be fun for the whole family. You can get them with one fin or, shortboard style, with three.

MALIBU

FUNBOARD

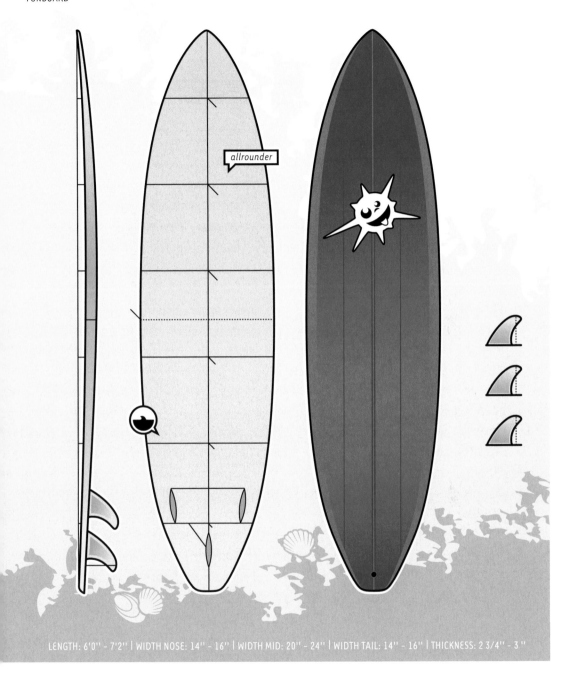

LENGTH: 6'0" – 7'2" | WIDTH NOSE: 14" – 16" | WIDTH MID: 20" – 24" | WIDTH TAIL: 14" – 16" | THICKNESS: 2 3/4" – 3"

MALIBU FUNBOARD

As the name suggests, the funboard is mainly there to help you have fun in the water. It doesn't have a specialized shape, which means you can surf with it in pretty much any conditions. If you want to have fun with your board, or you need an all-round board then this is the right one for you. It's ideal for advanced beginners and for anyone who wants to work their way up to a short-board.

SHORTBOARD

FISH

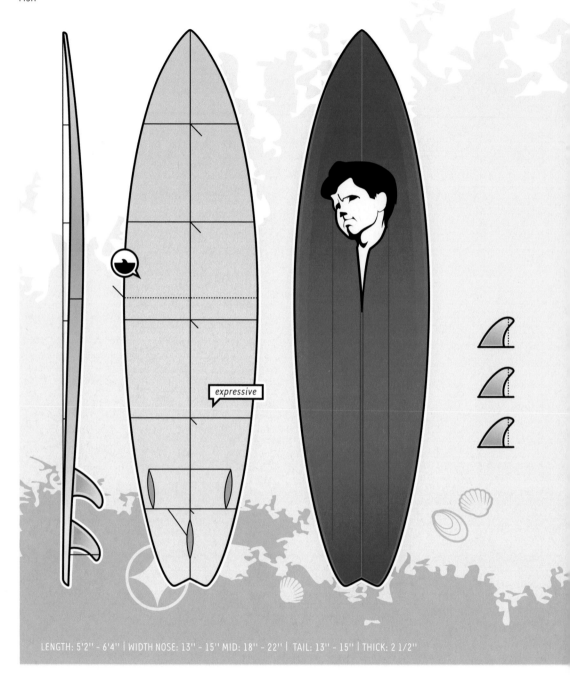

expressive

LENGTH: 5'2'' – 6'4'' | WIDTH NOSE: 13'' – 15'' MID: 18'' – 22'' | TAIL: 13'' – 15'' | THICK: 2 1/2''

SHORTBOARD FISH

This shape is a big favourite along the German coasts. Its main characteristic is its round nose, wide voluminous blank with a swallow tail. This board is made for small to medium-sized waves, is fast and easy to control due to its usually wide swallow tails. The advantage with a "fish" is that you can catch the wave quite easily and keep your speed up too. That's an important aspect, especially in our rapidly shallowing mushburgers, so as to be able to surf in these shallows.

SHORTBOARD

GUN

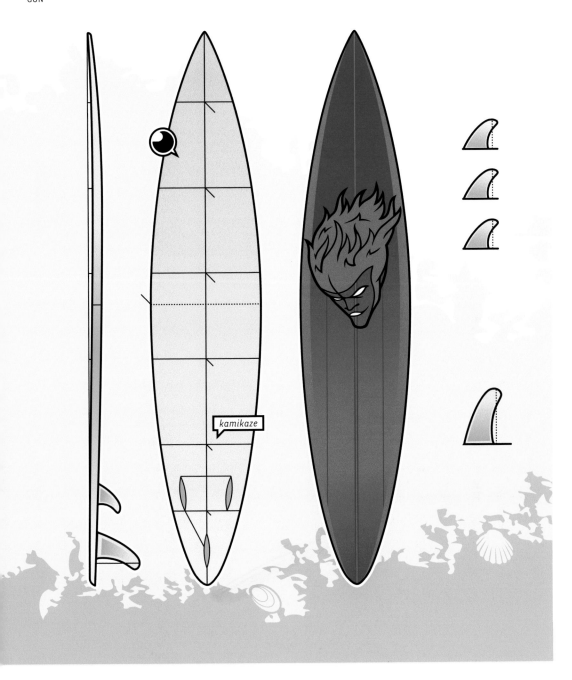

kamikaze

SHORTBOARD GUN

The GUN is the large version of a shortboard with a pin-tail for high speed and thus for large waves. Because of its large size you can paddle into big waves. The performance of a gun when taking curves depends on the speed and on the size of the wave. They aren't incredibly flexible but they are easier to steer at high speeds. Then there are the so-called semi-guns. These boards are useful when the waves are too big for shortboards and begin to break hollow.

SHORTBOARD

STRAPBOARD

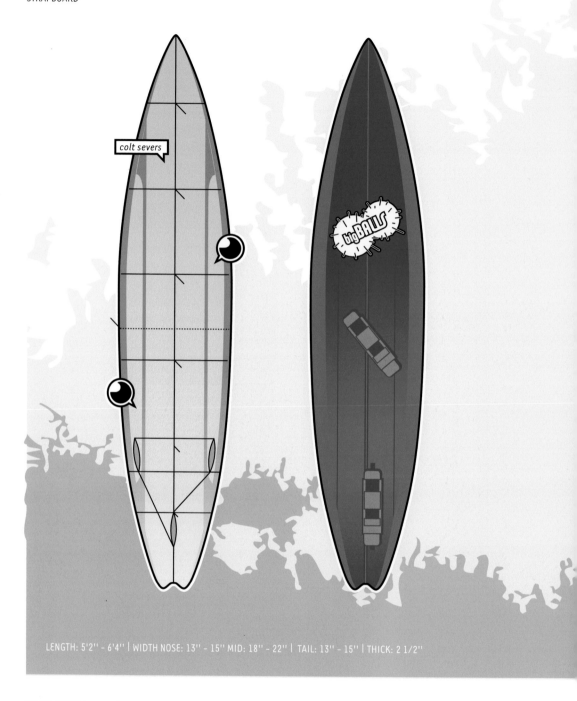

LENGTH: 5'2'' – 6'4'' | WIDTH NOSE: 13'' – 15'' MID: 18'' – 22'' | TAIL: 13'' – 15'' | THICK: 2 1/2''

STRAPBOARDS haven't been around for all that long in terms of the history of surfing. They were invented out of a need to surf ever-larger waves. Waves get faster the larger they are, and these can't be outpaddled with mere physical strength. They are so large that they wouldn't be surfable with a GUN. Strapboards are somewhat smaller and heavier and have foot straps so that you have better control when surfing at these incredibly high speeds. In order to underline these characteristics they also have special channels at the tail and concave upper edges which guarantee accurate steering. With these boards you will be safe to surf waves up to a height of 100 feet or more. There are also shapes that provide good surfing, like a shortboard, (easily controllable and flexible). They are meant for "airs" and waves that are difficult to get to.

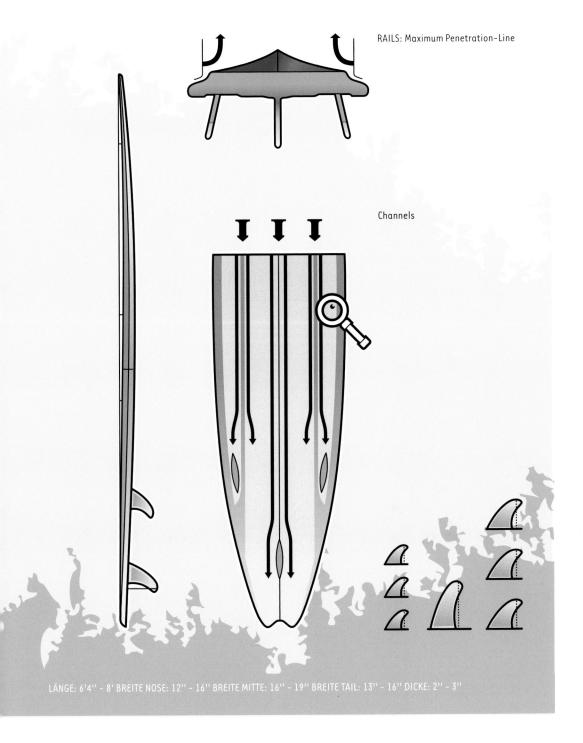

RAILS: Maximum Penetration-Line

Channels

LÄNGE: 6'4'' – 8' BREITE NOSE: 12'' – 16'' BREITE MITTE: 16'' – 19'' BREITE TAIL: 13'' – 16'' DICKE: 2'' – 3''

SPECIAL TAIL CHARACTERISTICS

These boards differ from the usual surfboards in shape, weight and size. The rails on the strapboards are specifically designed for extreme speed and guarantee absolutely accurate steering. They don't slide away as easily and aren't thrown by a few choppy waves. There are special channels in the tail that allow the water, arriving at a much higher speed, to run off without allowing air to get under the tail. The latter can cause the board to slide to one side, making control extremely difficult.

BOARD EVOLUTION

BEFORE THE FIFTIES

Contrary to common belief, the surfboard has been around since the 6th century. It gained in popularity in North America only during the late 19th century. The tradition of surfing, (standing upright on a board) was exported from the Polynesian islands to Hawaii and was known about from the mid-18th century onwards. Surfing was a religion-associated leisure activity and was initially reserved as a sport for royalty. Their boards were roughly shaped and usually made of solid wood, weighing nearly 150 lb (75kg). Ground coral was used as a sanding tool to smooth the board. Then it was rubbed down with bark or charcoal and finally treated with nut oil.

The western way of surfing was introduced to Australia at the start of the 20th century when Duke Kahanamoku, the Hawaiian Olympic swimmer, demonstrated his surfing skills during a visit there. In the early 20th century the board itself went through several transformations. It developed from a solid redwood board of 10-foot length which behaved like a sponge as soon as it came into contact with water. Reflecting the technological level of the twenties, this became transformed to a hollow, longer and lighter board (around 16-feet long), also made of wood, and known as the "Cigar Box".

In the thirties, the hot curl boards appeared, made of plywood. After the Second World War, people started using balsa wood. At that time, a rudder served as a stabiliser for the board, and a thin layer of resin and fibreglass was added to protect the wood. The length of these boards was invariably 10-foot long. Board design during the fifties and sixties was based on this as the standard length.

THE SURFBOARDS OF THE FIFTIES

Surfboards in the fifties characterised the advent of modern surfing. Surfing had put its reputation of being just a fashion trend behind it and now took on the aura of a glamour sport. Although a major part of the board and material designs were based on the use of balsa wood, the fifties were a time of great influence, in terms of surfboard technology. The board was still long like its predecessors (10ft 6 inches on average), but for the first time it was thrown into the melting pot of industrial mass production.

The most significant development of the late fifties and early sixties was the use of Polyurethane foam rubber and fibreglass, which now serve as the basic material for all surfboards. The most important aspect of this new development was the considerable weight reduction. Due to the lightness of the new boards, more flexibility with bigger volume was attained, and production was simplified, making larger market accessibility possible.

THE SURFBOARDS OF THE SIXTIES

In the sixties, the surfboard was transformed. Like the youth culture revolution, the surfboard came to symbolise a kind of subculture. The era of the longboard was nearing its end, just as balsa wood was eclipsed as a building material by fibreglass and polyurethane. The introduction of the shortboard turned virtually every surfer into a shortboarder over night. Surfing was back'in'. Between 1968-70 the average length of a surfboard shrank from 10 to 6 feet. The great advantage of this new sized board was its speed. The shortboard was extremely flexible and allowed the surfer to take the wave not only vertically, like a longboarder, but also to dive into the tube and perform daring turns in and on the white water. The shortboard

went through a few transformations in its early days. The tail grew gradually narrower and looked more like a modern pintail in its design, and so offered more stability in a turn. Shortly afterwards the nose was raised somewhat, a flexible fin was added, and thus, the basis was created for an all-round performance surfboard. The exciting thing about these developments was that surfers could really push the limits of what was possible on a shortboard. Radical turns and high speeds simultaneously became reality. In 1973 Jack O'Neill finally invented the leash. Thanks to this elastic and resilient leash, it was now possible to stay out after a wipe out and not have to return to the shore, to comb the beach for your board. You can get leashes in different lengths. Which you use, will depend on the size of the wave. It attaches the back foot of the surfer to the tail of the board. A further milestone was the development of three variable fins. That meant the board could be used in variable conditions simply by adjusting the fins. Three fins also provided more stability and better steering in a curve. In addition, a broken fin could be easily replaced and this saved having to buy a new board. During the eighties things went quiet on the surfboard development front. The longboard had a revival that continued into the nineties. Nevertheless, the fact remains that fifty percent of surfers use the same type of longboard that was used 50 years ago.

THE NINETIES

During the nineties the surfboard industry recovered somewhat. The longboard, now fully accepted by the surf industry, became increasingly lighter. Just as in the development of any sport, surfboard design became ever more specialised so that a different type of board was created for pretty much every kind of wave. Development focused most on three elements: the surfboard rail, the tail design and the shape of the underside. Out of this, five standard surfboard designs crystallized. There was the fish, the shortboard (thruster), the Malibu, the gun and the longboard. Each board type had its own characteristics. The boards all had a stringer that guaranteed optimum rigidity. Also in the nineties, the first computer programmes appeared for designing surfboards. Just as the surfboard has developed, so has the surfer, and thanks to these, it's now possible to surf waves that would've been impossible 50 years ago. The last major development of the nineties was probably the strapboard (tow-in board). Due to the straps on the board it was suddenly possible to surf waves over 40 foot. The only disadvantage of this board is that you need a jet-ski to get you out into the steep part of the wave. That's because of the enormous size and speed of these waves. Above a certain wave height, it just isn't possible through physical strength alone to reach the enormous speed needed with a normal gunboard.

THE SURFBOARD HAS DEVELOPED FROM ITS POLYNESISCHEN ROOTS INTO A MULTI-MILLION DOLLAR INDUSTRY. THIS SELL-OUT WILL CONTINUE BUT FOR MOST SURFERS THE SURFBOARD WILL REMAIN A SPECIAL SYMBOL — A WAY OF ACHIEVING PEACE OF MIND AND SOMETHING THAT BRINGS THEM CLOSER TO THE ENDLESS TRANQUILITY OF THE DEEP BLUE SEA.

Bunny♥2

SUN - BURN - PROTECTION

SUNBURN AND WAX FIGURINES

FOR EXTERNAL USE ONLY

Essentials that belong in every wave-rider's bag are: a good water-proof sun cream and the right board wax. Both are only intended for external use. Thanks to our ozone layer (or what's left of it), the sun isn't what it was 50 years ago. Due to the added reflection from the water, the sun is even stronger than onshore, and this can quickly give you a nasty sunburn. You should try to cover those body parts that aren't protected by the wet-suit. In particular your nose, which projects out more than other parts of your body.

But make sure you don't run around the beach oiled like Arnie on muscle beach, because otherwise your board will become as slippery as an eel and no amount of wax can save you then. Make sure the cream is resistant to seawater and don't be afraid of putting too much on. Better that than a painful evening with your raw skin being raked by the sand. Doesn't look good.

When it comes to the board wax, you want to make sure it's the right kind for the specific water temperatures, which means:

There's wax for warm and cold water as well as for mid-temperatures. The temperature will determine the consistency of the wax on your deck, so it's important to choose the right kind. And dirt, sand and sun shouldn't come into contact with your board when it's on land. Sun plus wax makes liquid wax, sand plus wax makes for nipple burn. It's better to put on a new layer of wax regularly, applying it with circular movements. To be able to strip the wax effectively, lay the board in the sun for a while and then scrape the wax off with a plastic spatula, a credit card or something similar. If it's soft, it's easy. All I can say on the topic of sun cream and blocker is: make sure it's 100% waterproof, so as not to leave oil slicks in the water (oil tankers will do that for you) and to prevent your nose being burnt to a cinder. Sun blocker prevents most UV rays from reaching your skin. Sun gels are better for your skin as they contain no emulsifiers, reducing the risk of an allergic reaction. For very pale skin, zinc cream is the best. This has to be applied as a covering layer. Available from chemists or a surf shop. The downside is that some people are allergic to zinc and, because it absorbs water from the skin, it tends to dry it out.

AFTER TIME IN THE SUN, MAKE SURE TO MOISTURIZE TO GIVE THE SKIN BACK ITS ELASTICITY, VITAMINS AND MUCH, MUCH MORE. BUT MAINLY MOISTURE.

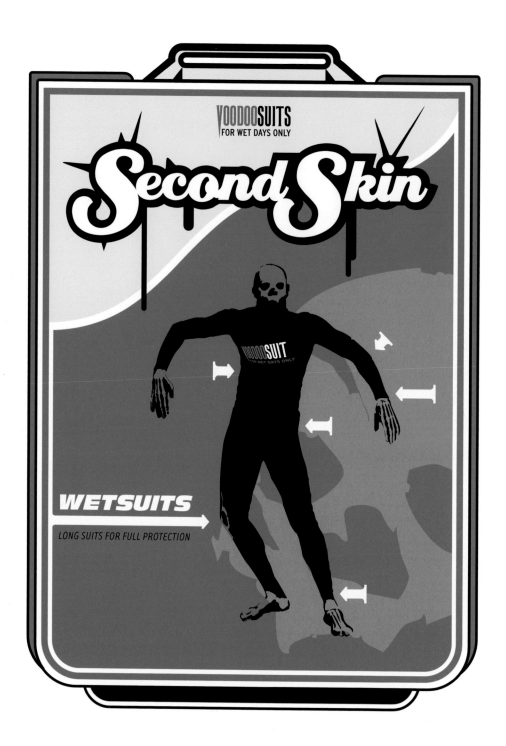

SWEET SUITS

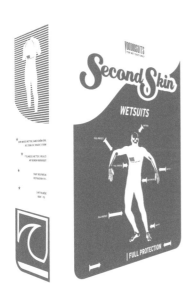

FULL SUITS are for cold or cool water temperatures or for longer sessions in the water. Longsuits are best for keeping warm; depending on the thickness of the Neoprene they are more or less comfortable to wear. There are lightweight long-suits but also special dry suits for cold winter days. Just ask yourself what you would prefer: to spend the money on a short holiday in warmer climes, or spend it on a dry suit, so you can spend the whole winter in the water off the Danish coast. Think about it…Hm.

Over the years, most LONG-SUITs have become very comfortable to wear, almost like a second skin, and you shouldn't shy away from a long-suit or buying one, just in case you encounter an emergency freeze.

SPRING-SUITS. The next in the array of warming suits. With long legs and short sleeves this suit combines the best of both worlds: comfort and good protection. These days, using new technologies, industrial production creates materials that are water resistant, soft and stretchy, as well as with warmth-reflecting layers that are incorporated into the second skin.

You should perhaps check that the proportion of black Neoprene is relatively high, as it absorbs sunshine and transforms it wonderfully into warmth. That can mean an hour or two more in the cold water without emerging totally exhausted.

SHORTYs are the most comfortable alternative apart from LYCRA SHIRTS for keeping your body warm. You have maximum freedom of movement with hardly any pressure points or tight spots. It's the ideal wet-suit for the Atlantic coast from May, June till September. Obviously that will depend on actual daily temperatures. Also, wet-suits in general protect you from the abrasion when you come into closer contact than planned with the seabed. Areas like the lower back, chest and stomach should always be held as warm as possible because otherwise all your energy will be used up to keep you warm rather than to power your muscles.

LITTLE FROG BUTTS

Your mood will change like the ups and downs of the weather in April, if you haven't got the right wet-suit. If it's too big you'll freeze faster, if it's too small it will hinder your movement and your blood circulation. There are different suits for different kinds of weather, so it's useful to take advice from a knowledgeable assistant in your surf shop. These are the important points to watch out for: the suit mustn't, as I mentioned above, be too tight, as you will be less mobile, your circulation will be affected and you will lose your strength more quickly.

At the other extreme, the suit should never be too loose; otherwise it won't keep you effectively warm. A thin film of water should be able to get under the suit, and it should reach body temperature in no time so that you don't have to waste energy reserves just to keep warm. Also, don't forget that the suit will stretch a bit after the first couple of sessions. When it comes to buying a suit, always consider weather conditions. Don't try to save pennies here; a good suit will always be worth paying for.

Before you buy a suit think about where you'll be surfing and what the water and air temperatures will be like. Decide between a LONG-SUIT (long sleeves, long legs) a SPRING-SUIT (short sleeves/long legs) or a SHORTY (short sleeves/short legs), which are described in detail below. Oh, and do make sure you wear it the right way round. The zip should be at the back!

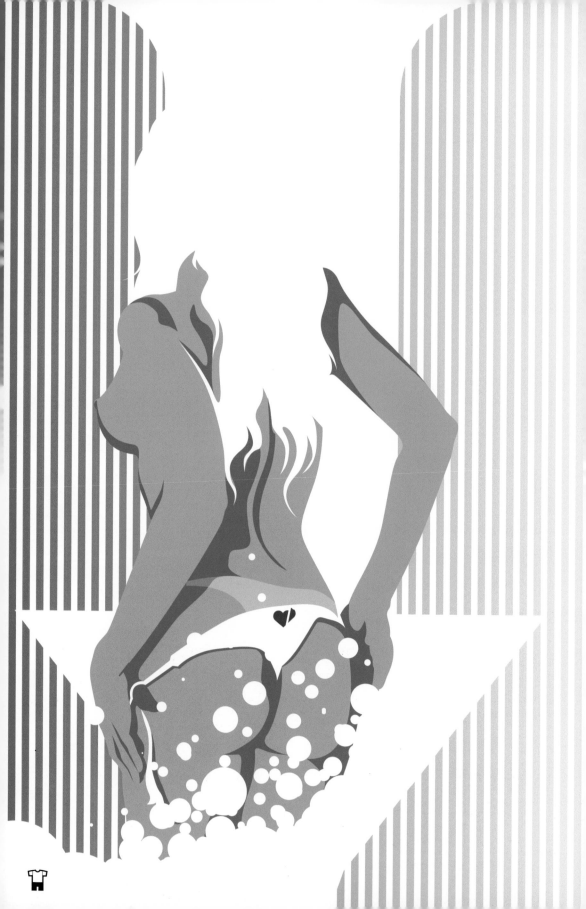

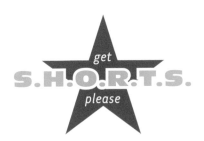

PANTSDOWN

THE MOST SENSITIVE TOPIC ON THE WORLD'S BEACHES HAS TO BE MALE BEACHWEAR. IF YOU WANT TO SURF, THEN PLEASE DON'T DO IT IN DAD'S TIGHT YELLOW BATHING TRUNKS, GRANNY'S THONG OR IN YOUR OWN PRIVATE FINE-RIB UNDERPANTS. GET S.H.O.R.T.S. PLEASE.

Of course it's up to you, and I am the last person to tell you what to wear, but one thing is for certain: surfing is style from start to finish. From the movement of the waves, to the cars and bikes, from the clothing down to the boards. I'm not one to follow trends or to buy the latest must-have. Surfing is still a sport that doesn't need much in the way of equipment and half of what you need is given you by nature.

The rest is a waxed board, a leash and some shorts. A bit of cash, a sleeping bag, and that's the summer sewn up. As I said, shorts, not a tight pair of trunks to match the colour of your highly polished Opel, creating a wonderful image in the sunset on the Côte d'Azure. I'm convinced that these ball-breakers won't even turn on an old granny, never mind if you've spent 70 euros a month in the workout gym all winter getting your body into shape. The top three best combinations are of course: Lycra over swimming trunks, T-shirt (white) over swimming trunks, and the silent no. 1 for me: T-shirt (white), tight trunks from dad's early swimming days and black ankle-length Neoprene shoes contrasting with pale white skin. That

sounds really snide, but it's meant to be ironic. Everyone has their own preferences and everyone's had their own experiences, but my 6-year-old rip-curl shorts have more style and character than any Ian Thorpe Speedo trunks.

I wouldn't touch this subject if shorts didn't have a long tradition in surf sport. They are more comfortable, more hardwearing and more functional than anything, as I don't have to carry my wallet in a hip bag over my trunks, or even in my trunks. Instead there are up to three or four integrated pockets in the shorts. They also protect sensitive areas of the body from the sun and ensure that you don't damage your lower body too much. Not to mention how comfortable they are.

SHIRTSTYLEZ

When it comes to the appearance of a surfer, you can't ignore the surf shirts. They have a long and rich cultural tradition. It was probably started by some kind of promotional company or team shirt manufacturer. Every board-making firm has their own surf team and their own logo, like the ZEPHYR surf team in California, LIGHTNING BOLD on Hawaii or TOWN AND COUNTRY, who put their teams forward for competitions as company representatives. The surf shirt as a recognised emblem was born and soon found its way into the surfing product market.

The shirts became increasingly illustrative and expressed in a simple and graphic way the feel of the surfing life. Soon every surf company, like O'Neill, Rip-Curl or Quiksilver had their own shirt labels with cool prints. These had strong links to the Hawaiian shirts of the fifties and sixties, which in turn were based on the hand painted shirts of the early 19th century. The fashion soon spread from Hawaii to the coast and from there around the world.

After the surf boom of the sixties, the hippies pushed the surf shirt to new limits and it was adapted as a marketing label. The shirts were brighter and gaudier than ever before. A conservative reaction to all this colour followed in the seventies. So surfing is not just a sport, it is a way of life and of course also a fashion. In the eighties there was a big surf and skateboard revival, which led to a total commercialisation by the clothing companies.

Overnight all the kids in America were running around with shirts from companies like RUSTY, QUIKSILVER or GOTCHA, combined with the concept that surfing is the ultimate lifestyle. Slowly the rest of the world began to understand this.

This revolution was televised, and through magazines and films the lifestyle was communicated to the rest of the world.

THE FIRST SURFER WHO WAS SPONSORED BY A CLOTHING COMPANY WAS DAVE KAHANAMOKU, WHO WORE THE BELOVED "PINEAPPLE TWEED" SHIRT FROM KAHALA, EMBROIDERED WITH A ROYAL HAWAIIAN COAT OF ARMS.
HE WAS PAID 50 CENTS PER SHIRT SOLD. KAHALA'S MOTTO WAS "LIFE ON EARTH WILL BE SECURED BY LIVING RIGHT". THE SURF SHIRTS QUICKLY BECAME POPULAR AND SO CREATED THE BASIS FOR THE SURF LOOK AS WE NOW KNOW IT, AND FOR THE SURF INDUSTRY THAT HAS A MULTI-MILLION DOLLAR TURNOVER ANNUALLY.

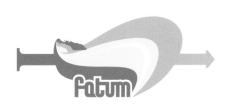

HEY! WANNA I GO OUT FOR A RIDE? NO THANKS NO THANKS? I WHAT DOES THAT MEAN? I DON'T WANNA GO. GO WHERE? FOR A RIDE A RIDE?! NOW THAT'S A GOOD IDEA. FUCKA. O.K. LET'S GO.

"BLUE VELVET" a film by DAVID LYNCH

SURFM OBILES

LET'S GO FOR A RIDE

NO FAST CARS – JUST COOL VEHICLES AND NICE HOTRODS

FURTHER CULTURAL HIGHLIGHTS ARE THE SURF MOTORS. RIGHT OUT THERE IN THE FRONT ROW IS THE GOOD OLD WOODY BY FORD, WHICH WAS COPIED AND PRODUCED IN MULTIPLE VARIATIONS BY DIFFERENT CAR MANUFACTURERS, FOR EXAMPLE CHRYSLER. THE CAR WAS LARGELY HAND MADE AND SURVIVED A GOOD 50 YEARS. THIS REMAINED SO FROM THE TURN OF THE CENTURY INTO THE FIFTIES, WHEN THE FIRST MASS-PRODUCED CARS WERE MADE COMPLETELY OF METAL.

THE WOOD CHASSIS HAD TO GO. EVEN THE BEACH BOYS SANG IN THE EARLY SIXTIES: "I LOADED UP MY WOODY WITH MY BOARDS ON TOP"

(LET'S GO SURFIN'). RIGHT TO THE PRESENT DAY THE GOOD OLD WOODY HAS SURVIVED AS THE DEFINITIVE SURF CAR, EVEN THOUGH IT ISN'T PRODUCED ANYMORE. LATER ON, THE WOODY WAS REPLACED BY THE BULLI FROM VOLKSWAGEN AND IS STILL DRIVEN TODAY. ONE COULD ALMOST CALL IT THE EUROPEAN WOODY. AS LONG AS TWO BOARDS FIT IN AND IN AN EMERGENCY YOU CAN SLEEP IN IT. WHAT MORE CAN YOU ASK OF A CAR?

AUTOMATISM

THE ULTIMATE ROADTRIP

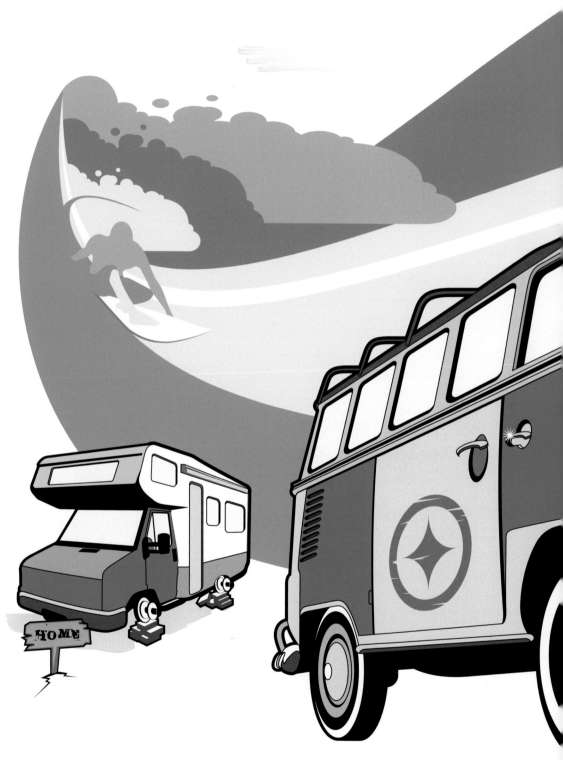

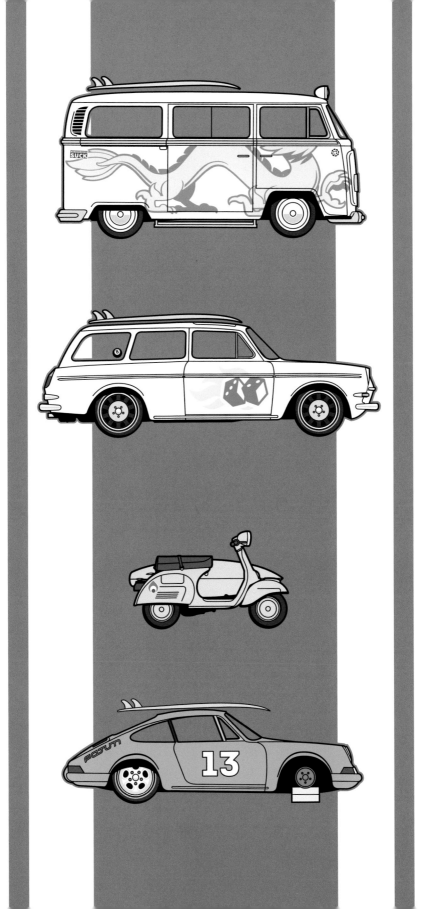

SIMPLY CRUISIN'

We almost forgot to mention one of the most important elements of our time, the good old beloved BEACH CRUISER that has also found its way into our urban space. We can now have the feel of cruising around in a tarmac version. The beach cruiser was in the nineties what the Holland bike was in the eighties. Of course you can spot the difference between fake and real cruisers. It's assumed that a beach cruiser only has to look cool and do the job with little fuss. Road suitability was seen as being pretty much irrelevant - it is a beach cruiser and not a road cruiser isn't it? On the other hand, the cruiser is a typical retro-fashion phenomenon that will continue to exist within the subculture. But in the real world it will soon be re-placed by some other vehicle or retro-bike.

Fat Tire

BEACH LIFE

THE ANNOYING MIDDAY WIND IS BLOWING ITSELF OUT, THE SUN IS SET-
TING. SOFT LIGHT BREAKS OVER THE GOLDEN SURFACE OF THE WATER.
YOU TAKE YOUR BOARD, WHILE THE REST OF THE GANG ARE GETTING
THE CAMP FIRE GOING, GETTING THE BBQ ORGANISED AND PREPARING
TOFU AND VEGETABLES. THE SEA IS EMPTYING AND YOU KNOW, WHEN
EVERYONE SETTLES DOWN TO EAT, THE LAST WAVES OF THE DAY ARE
DISAPPEARING.

If you're not into Club Med or Center Parcs then this is the place for
you. After a great day surfing, hanging out on the beach and relax-
ing is the best thing. You don't need much to be happy and fulfilled
as long as you're in your element. Those will be the best days of your
life, till your holiday's over and you head for home, your rucksack
full of memories and good feelings and a joyful anticipation of re-
turning to your beach as soon as possible. No worries, no responsi-
bilities. UNREAL REAL LIFE.

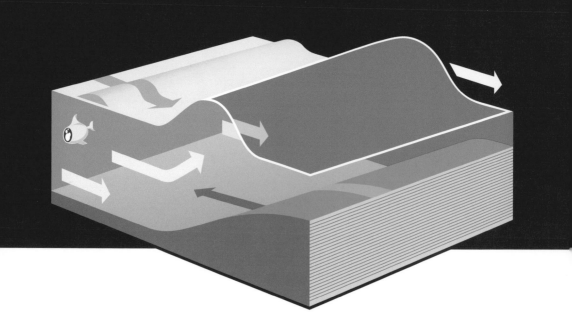

BREAKIN' WAVES

BEACHBREAK

The BEACH BREAK is the most common type of wave break in Europe. Its sandy seabed is constantly shifting and doesn't give the water much upward thrust, so the waves can't break as cleanly as with a reef break. That means that the waves can only break hollow above a certain swell level. They are also slower and don't have much power. One advantage is that they are relatively safe (with the exception of RIP CURRENTS).

REEFBREAK

The REEF BREAK. This is where the nicest waves are mass-produced. Because of the hard seabed, the accumulated energy is given an optimum thrust. Also, the fact that a hard seabed rises much more steeply than the usual sandy beach. That's why the waves, especially during an ebb tide, usually break cleanly, and hollow, providing great tubes. But beginners should stay clear, as the danger of getting hurt is pretty high.

REEFBREAKS AND BEACHBREAKS

For millions of years waves have been breaking ceaselessly on the coasts of our blue planet. Day in and day out they shape our planet. A complex energy system, a complex synergy effect carries the most perfect product of nature thousands of miles across open water to our coasts. The awesomeness of nature's destructive force sends a shiver down the spine, but simultaneously brings forth a sense of amazement at the power and the energy it represents. In the face of these forces humans become aware of how miniscule they are. Water has always exerted a spiritual pull on people, especially in those regions where people have a strong relationship with the great water masses, but they are particularly vulnerable when they depend on it for gathering food to survive.

If you want to be a surfer, body and soul, then you have to feel this connectedness to water, you have to understand, love and respect the ocean. Our modern urban life often leads us to forget that we are a mere tiny part of a complex ecosystem. We have to be reminded that we consist of 94% water. Every cell, every blood corpuscle consists of water. And when you enter the big pond you have to feel that; how that energy is a part of you and you are a part of the whole. And if you manage to surf a wave then you will perhaps understand what it is to be at one with water and nature. You are entering a world of soul and rhythm.

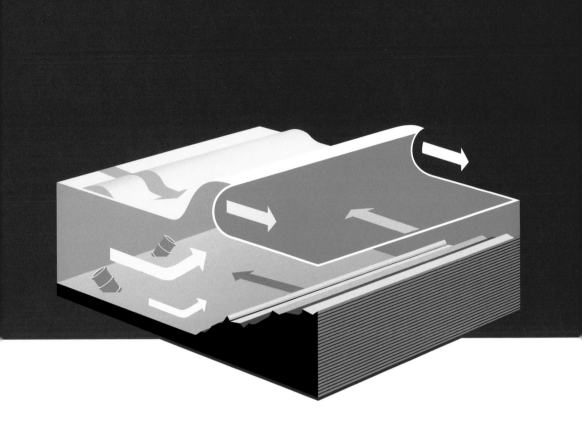

As you can see, pressure from the incoming water mass is compressed the shallower it becomes, and this leads to its acceleration and a rise in sea level. The higher the kinetic energy and the faster the surf, usually due to a storm, which may be close by or further away (the further away a storm or hurricane, the greater the incoming energy), the steeper and larger the wave. The same applies to the seabed; the harder and steeper it is, the more it thrusts the incoming current upward, creating an anticlockwise vortex (especially with reef breaks at ebb tide), making larger, faster, more powerful and clean-breaking waves, with the accompanying tube.

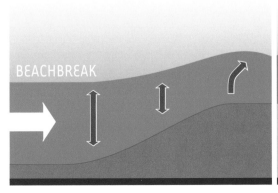

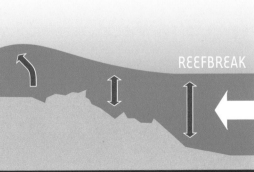

MOONSTRUCK*

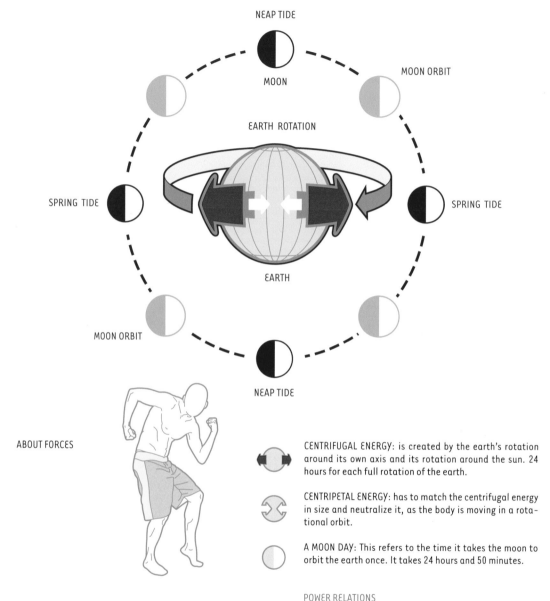

NEAP TIDE

MOON

MOON ORBIT

EARTH ROTATION

SPRING TIDE

SPRING TIDE

EARTH

MOON ORBIT

NEAP TIDE

ABOUT FORCES

CENTRIFUGAL ENERGY: is created by the earth's rotation around its own axis and its rotation around the sun. 24 hours for each full rotation of the earth.

CENTRIPETAL ENERGY: has to match the centrifugal energy in size and neutralize it, as the body is moving in a rotational orbit.

A MOON DAY: This refers to the time it takes the moon to orbit the earth once. It takes 24 hours and 50 minutes.

POWER RELATIONS

As we all know by now, the earth is not a flat disc, at least not for most of us. It is an elliptical, rotating sphere, whose force is concentrated towards its core. Gravitation holds all this together.
As the earth rotates and at the same time orbits the sun, we are subject to the equal impact of gravitational and centrifugal forces. Due to its elliptical form and the earth's rotation, there is less water at the poles than at the equator. In addition, the moon, the closest planet to us, also has its own gravitational force, which affects our own planet. That's what creates the tides. Ebb and flood, high tide and low tide. The tides are cyclically stronger or weaker depending on the angle at which we find ourselves in relation to the moon, and the angle of the moon to the sun.

The side of the earth facing the moon is more strongly affected by the moon's gravitational pull than by the centrifugal force of the earth's rotation. This causes a "mountain" of water, the so-called zenith flood. This is strongest at that point on the earth's surface that lies at a 90° angle to the moon. On the side facing away from the moon, the centrifugal force is stronger than the gravitational pull. Here a second "mountain" of water is created, the so-called nadir flood. Nadir is the point directly opposite the zenith. At the earth's poles they both have the same power and so neutralize each other. This means that sea level at the poles are at their lowest.

SPRINGTIDE AND NEAP TIDE

MOON DAY: THE TIDES COME AND GO TWICE EVERY MOON DAY, WHICH, AS ALREADY MENTIONED, IS 24 HOURS AND 50 MINUTES LONG. EVERY 12 HOURS AND 25 MINUTES THE WATER REACHES ITS HIGHEST OR LOWEST LEVEL.

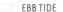 SPRING TIDE: is when the sun the moon and the earth are on one axis and exert the greatest gravitational pull on the water's surface. This means that the full moon and the new moon produce the highest tide levels. Spring tides happen twice a month.

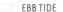 NEAP TIDE: At this time, during half moon, we experience the least difference between ebb and flood levels. The earth's centrifugal force exerts an elliptical pull on the water's surface, while the orbiting of the moon exerts its strongest pull at that point where it is at a 90° angle to the earth.

EBB TIDE
Let's go! The best constellation is when it's low tide in the morning. If you also have a gentle seaward breeze, then you couldn't wish for anything more. You can see from the illustration that the water is shallow enough to produce a good wave break. The shallower the water, the steeper, faster and cleaner the waves break.

FLOOD TIDE
You can see clearly that there isn't much space between water and sky. Not even an experienced pilot would fly through there unless he's in a hydroplane. Seriously, though, due to rising water levels the incoming water only gains enough power shortly before it reaches the shallow beach and then breaks. The waves parallel to the sandbank run in very irregularly and only break properly at a certain height. But not cleanly.

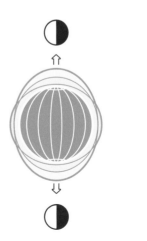

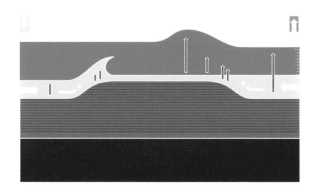

CURRENTS

THE No.1 KILLER FOR WATER SPORTSMEN AND WOMEN. EVERY ONE KNOWS THIS ONE, YOU THROW AN APPLE INTO A ROUGH SEA AND AS IF AN INVISIBLE HAND IS CARRYING IT IT'S DRAGGED UP THE COAST UNTIL IT'S EITHER SWEPT OUT TO SEA OR ONTO THE BEACH.

LONGSHORE CURRENT

CURRENTS ON LONG BEACHES

LONG-SHORE CURRENT sounds quite calm and safe and in reality it is, up to a certain point. But the currents, no matter how strong or weak, should never be underestimated. Especially in areas where there are sandbanks, the situation can change from one moment to the next. If that should be the case and you find yourself in a similar emergency situation don't try to fight the current, whatever you do. Save your energy until it makes sense and there is a chance to escape the situation or wait for outside help. Long-shore currents are perfectly natural, as the incoming water and its energy, has to be transmitted in some direction. If the swell comes from diagonally left as shown in the picture, the current will run to the right, along the coast. If the swell comes from the right the opposite will be the case.

When paddling into the surf, these currents can be helpful and save you a lot of energy. When in the open sea, you should note a spot on land that will help you to orientate yourself and give you an indication of how strong the current is and how far you're drifting in a fixed time. On some days you may be more concerned with trying to keep to a fixed spot than with surfing. But that's rarely the case.

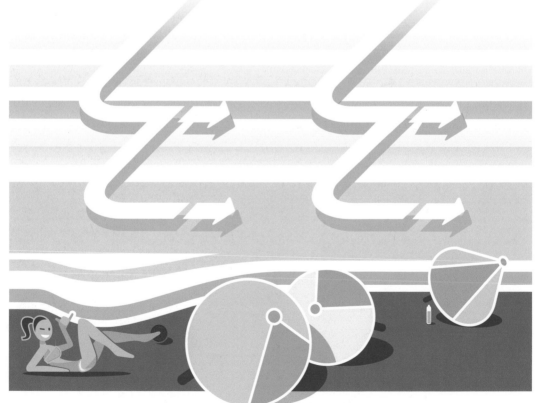

CURRENTS ALONG THE COAST. IF THE SWELL IS MOVING FROM RIGHT TO LEFT THE DIRECTION OF THE CURRENT CHANGES AND SO WILL THE PIECE OF LAND ON WHICH YOU END UP AFTER DRIFTING.

R.I.P. CURRENT

TIME TO GET SERIOUS. IF YOU NOTICE AN AREA BETWEEN THE WAVES THAT SEEMS DIRTY AND FULL OF LITTLE CHOPPY WAVES THEN YOU SHOULD CHUCK A SECOND APPLE IN AT THIS POINT AND YOU'LL BE AMAZED THAT THE APPLE DOESN'T DRIFT TO THE RIGHT BUT IS PULLED STRAIGHT OUT TO SEA AT A SPEED OF AROUND NINE METRES PER SECOND. NO JOKE. STAY ALERT.

Nine metres a second is some speed. That's faster than an Olympic swimmer can crawl. RIP CURRENTS develop suddenly and disappear just as suddenly. The incoming water rips a hole in the sandbank - marked red in the illustration. Instead of the long-shore current to the right, the current, in effect, falls into a steep hole, that inclines steeply in the direction of the open sea. RIP CURRENTS don't always have to be as bad as I've described but they are absolutely unpredictable. The red area could just stretch over 100 metres but it could pull you out two kilometres as well. And then the joke is over. Try to avoid this area as soon as you become aware of it and if you do ever find yourself in this situation you should definitely read on. First of all, whatever happens, whether you're the person

in the water or the person who's discovered the one in need of help, stay calm. Try to get noticed, or alert the coast guards. The red area isn't usually wider than 50 to 100 metres. Never try to fight the current. It's pointless. Save your energy and let the current take you. Remain in contact with your board, then nothing terrible can happen — at least for now. Try to get out of the area by paddling with the current in a diagonal direction, as shown in the illustration, and move metre by metre. If you're not strong enough to do this then attract attention by waving both arms over your head.

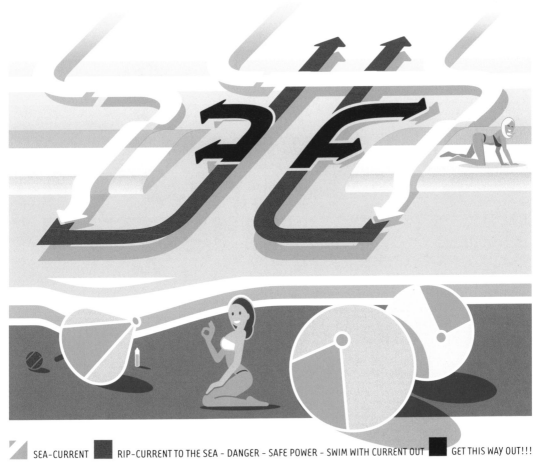

SEA-CURRENT RIP-CURRENT TO THE SEA - DANGER - SAFE POWER - SWIM WITH CURRENT OUT GET THIS WAY OUT!!!

METEOROLOGICAL GUIDE

A SHORT CHAT ABOUT THE WEATHER

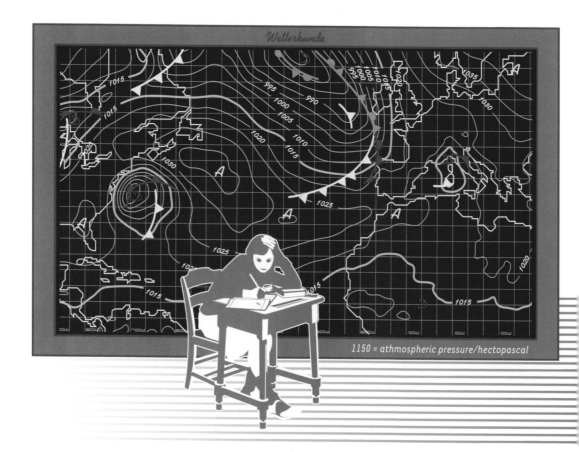

Wetterkunde

1150 = *athmospheric pressure/hectopascal*

HIGH AND LOW PRESSURE

THERE ARE LOW PRESSURE AREAS AND THERE ARE HIGH PRESSURE AREAS. THEY BOTH CREATE A CERTAIN ATMOSPHERIC PRESSURE AND WHEN A COLD FRONT AND A WARM FRONT MEET, THESE DIFFERING PRESSURES ALSO MEET, CREATING WIND (DEPENDING ON THE LEVEL OF DIFFERENCE). THE MORE THESE PRESSURE LEVELS DIFFER AND THE BIGGER THE PRESSURE CHANGES OVER A SHORT DISTANCE, THEN THE STRONGER THE STORM WILL BE.
THE STRONGER THE SEA WIND AND THE HIGHER THE SWELL.

WARM COLD CLOUDED STATIONARY

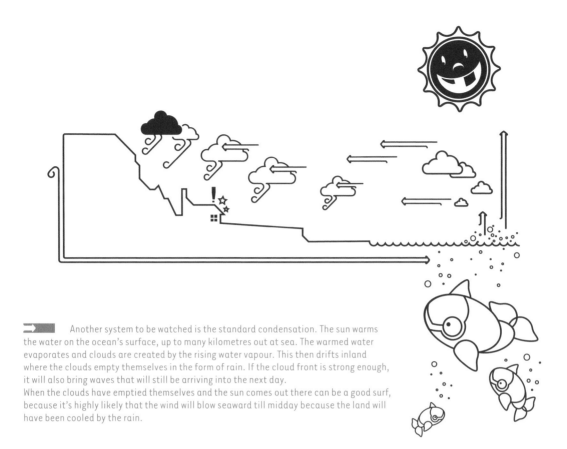

Another system to be watched is the standard condensation. The sun warms the water on the ocean's surface, up to many kilometres out at sea. The warmed water evaporates and clouds are created by the rising water vapour. This then drifts inland where the clouds empty themselves in the form of rain. If the cloud front is strong enough, it will also bring waves that will still be arriving into the next day.

When the clouds have emptied themselves and the sun comes out there can be a good surf, because it's highly likely that the wind will blow seaward till midday because the land will have been cooled by the rain.

WEATHER CURLZ

THE BIG WHEEL KEEPS ON TURNIN'

Weather is as ancient as humanity. That's a cliché if ever there was one! So that you can understand how things are interconnected and how one thing necessitates the other, I'll try briefly to outline the main components of climate and weather.

Weather happens. Our atmosphere keeps everything in flux and in a more or less stable system, as long as humans can learn to keep themselves under control. In nature everything takes place in cycles and after every action there follows a reaction. I'm not a climatologist or a meteorologist so I will try to outline things as simply and as briefly as possible, so as not to get tied up in complex issues. We

live in a complex but entropic system that has developed over millions of years. Low pressure will affect high pressure and vice versa. We live in a world in which the climate regulates itself and is continually changing. This has to do with global warming. In this chapter we are not talking about sunshine and good mood weather. A surfer is in a good mood when he has waves, and that's all there is to it. Waves, that is, not tsunamis or flood waves. They are created by wind, lots of wind, and wind is created when there is a large difference between a low pressure and a high-pressure area over the smallest possible range. In other words, when a cold front meets a warm front. Assuming a cold front with a pressure of 930 hecto-Pascals meets a warm front of perhaps 1100 hecto-Pascals then that tiny pressure and temperature difference creates a light breeze as the two fronts meet. If the cold front is strong, say 600 hPa and meets a strong high of around 1300 hPa then a powerful storm will ensue, creating large quantities of energy that a sea wind is whipped up and transfers the energies to the sea, whipping up the surface and waves into a frenzy. After the wind calms, the waves still continue to run on until they hit a coastline and finally break, without losing energy over thousands of kilometres.

01 warm front **02** cold front **03** clouds and rain behind warm front **04** wind turns and clearing sky in direction of cold front increasingly changeable wind, low cloud cover, warmth and rain **05** rain, returning winds **06** clearing sky with gusty wind **07** abating wind

THE THERMAL LIFT

OF GLIDERS AND OTHER WINDBAGS

As a child I always asked myself why gliders always stayed in one place. My father always replied that the pilots were drunk and couldn't find their way down.

Many years later I had my own drunken experiences with the forces of gravity. Later, I realised that glider pilots follow the thermals.

Thermals are created when the air on the ground is heated up and then rises. Of course I still don't know why these men go gliding when drunk, but you don't have to know everything in life. But I understood that this warm rising air was what lifted the gliders up into the air, without their having to use an engine. Amazing. You could also put the problem this way: when you're holidaying on the Atlantic coast, and you hang your T-shirt out to dry and it falls to the ground to the left of the washing line, only to lie to the right in the evening.

Before you complain to the campsite manager and you blame half your camping neighbours, let me explain why it happened. When you get up in the morning, the air over the ground and the earth itself has cooled off, just as the water has. But water can store warmth more efficiently than the land can. The land has cooled off but the sea hasn't done so quite as much, which means that the cold air is pulled by the warm air out to sea. During a sunny day, the land warms up again so that around midday when the heat is at its greatest the wind (the thermal situation changes) will turn and blow back inland. The results are quite important for surfers. The incoming waves are hardly disturbed by an offshore breeze. What happens is that the waves are blown very smooth and clean. Choppy waves disappear and the earlier you get up the better the conditions. Towards midday when the thermals are causing the wind to blow back inland, the water becomes choppier which means bad waves and not so great for surfing.

So, don't forget that. Getting up early is worth it, especially when you have a low tide in the morning. The conditions, if you're on the Atlantic coast between Bordeaux and Portugal, are ideal. Thermal winds blow everywhere in the world and even on your local gravel pit lake. Windsurfers will know what you mean when you mention Lake Garda, the Silvaplana lake, or Lake Walen in Austria, where you can tell to the minute when the wind will come and from which direction, at least in the summer. All you need then is a good night's sleep and a great morning.

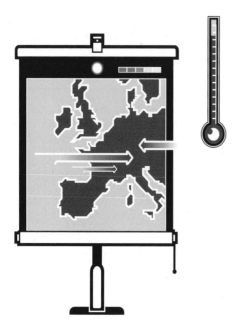

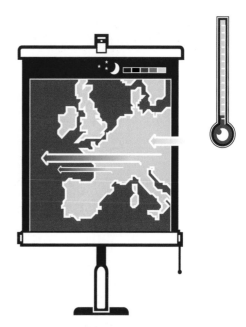

BIG WAVE PROGNOSIS

TOMORROW'S GOING TO BE A BIG DAY

We've just learned that getting up early pays off. If, after having taken in this scanty information you can now read a weather chart and make your own prognosis about whether the waves will come your way the next day, then so much the better. To make doubly sure, you can find wave charts on the Internet. They will tell you the height of the waves in specific areas, and also provide you with a prognosis of where and when you will encounter swells and, in general, what the situation on the water will be like.

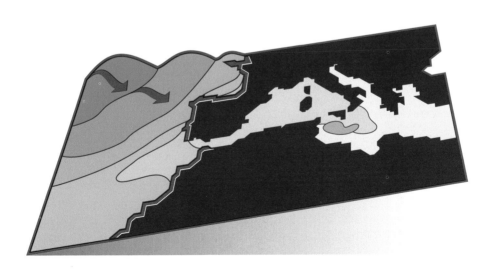

DANCER ON THE BEACH

→ A CHAPTER TO GET YOU GOING

WARM UP IN THE MORN TO STEER CLEAR OF CRAMP AT DAWN

The birds are singing as the first rays of sunlight lure you out of your sleeping bag. You can hear the surf beyond the dunes and there's a light seaward wind blowing. The temperature is rising – you can tell it's going to be a great morning. You pack your equipment, grab a bite to eat – nothing too heavy – and wash it all down with a swig of cold milk. You rouse your buddies and tell them you were already down at the beach. You say there's nothing really going on, wave-wise, so they can carry on sleeping.

That's one way to reduce the number of people out on the water. But it's also an effective way to reduce the number of buddies you have. So instead, you wake them up and you all have a fantastic morning's surfing. Nothing could beat that! So, come on, get a move on. The waves won't wait and the more time you waste, the greater the danger of the water being packed with people. The longer you wait the more packed it'll be. But before you dive into the cold water, sleep still in your eyes, you need to get your body ready with a warm-up. On the one hand, surfing is an incredibly physical, body-centred sport. On the other hand, it's something metaphysical – it's about your mind, a spiritual energy, it's something that repre-

sents an enormous psychological challenge. Do yourself and your body a big favour – never hit the surf on a full stomach. And always warm up beforehand – even if it seems tedious, your body needs to be mobilised gradually. If your muscles aren't warmed up, you could injure yourself. Most of you have probably known the searing pain of a cramp in your calf muscle, something it's obviously best to avoid. To stay in shape go for a thirty to sixty minute swim a couple of times each week. Do more or less depending on how fit you are. After your warm-up and stretches give yourself a five-minute rest, chilling out for a while. Take the time to check out the weather, the waves, the wind and get a feel for what the day may bring. If you're a beginner, the first rule is: don't head straight out on to the water. First, you need to practise your moves and, as far as possible, internalise them.

I spent many years windsurfing so I knew what to expect when I started surfing. I knew the moves and how to manoeuvre myself through them. Those who don't should finish reading this chapter before the next one takes you out into the surf.

MUSCLES BURN

THE MAIN IMPACT

RIDING WAVES IS EXTREMELY PHYSICAL. THE LADIES AMONG YOU WILL PROBABLY GET MOIST LIPS JUST THINKING OF KELLY SLATER AND HIS FELLOW SURF CHAMPS. THE AREAS OF YOUR BODY THAT ARE HIT THE HARDEST ARE IN YOUR UPPER BODY: SHOULDERS, BICEPS AND YOUR BACK. BUT DON'T UNDERESTIMATE THE POWER YOU NEED IN YOUR LEGS FOR HARD TURNS.

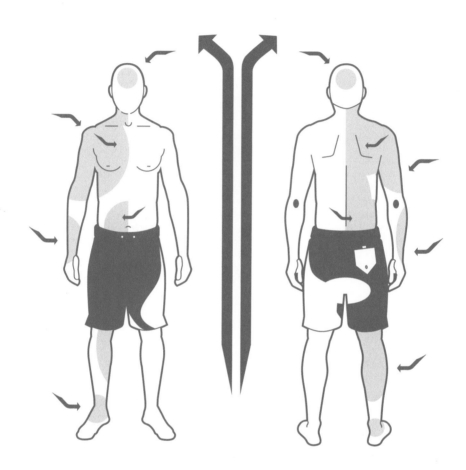

WARM UP EXCERCISE

FOR FRIENDS OF JANE FONDA'S WORKOUT

BE PREPARED FOR SORE MUSCLES IF YOU'RE FRESH TO SURFING. ALWAYS WARM UP BEFOREHAND — YOU DON'T WANT TO LEAP INTO THE COLD WATER WITHOUT DOING SO. TEN TO FIFTEEN MINUTES BEFORE THE FIRST SURF SHOULD GIVE YOUR BODY ENOUGH TIME TO LOOSEN UP. ON THE FOLLOWING PAGES ARE TEN EXERCISES. YOUR BODY WILL BE GRATEFUL.

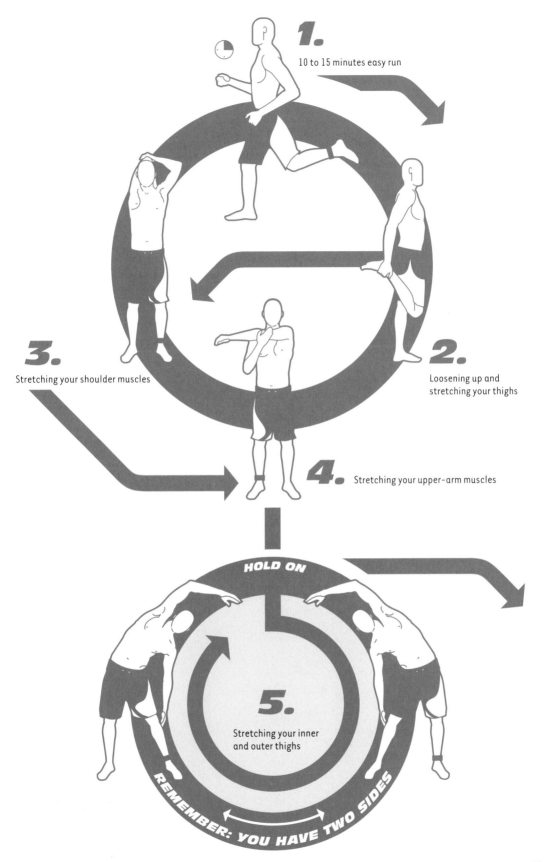

1. 10 to 15 minutes easy run

2. Loosening up and stretching your thighs

3. Stretching your shoulder muscles

4. Stretching your upper-arm muscles

HOLD ON

5. Stretching your inner and outer thighs

REMEMBER: YOU HAVE TWO SIDES

6.

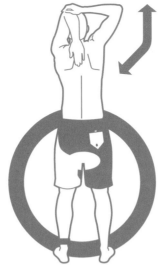

7.

Repeat stretching of shoulder muscles and loosening of shoulder joints

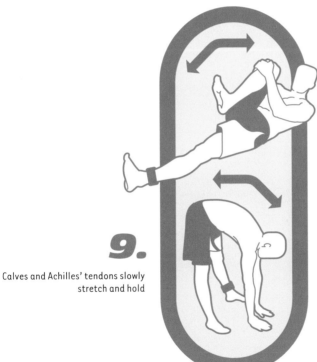

8.

Stretching of buttock muscles
hold – stretch – hold – stretch

9.

Calves and Achilles' tendons slowly
stretch and hold

10.

To really get going, do 10 to 20 press-ups
relax - stay relaxed.

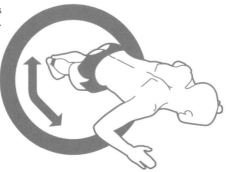

let's be friends

!DRY RUNS
WITH YOUR BOARD

GETTING TO KNOW MAN'S SECOND-BEST FRIEND

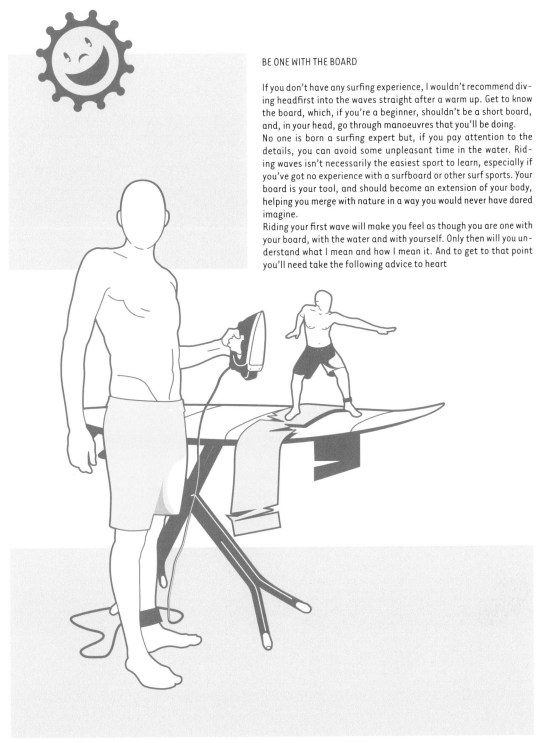

BE ONE WITH THE BOARD

If you don't have any surfing experience, I wouldn't recommend diving headfirst into the waves straight after a warm up. Get to know the board, which, if you're a beginner, shouldn't be a short board, and, in your head, go through manoeuvres that you'll be doing.

No one is born a surfing expert but, if you pay attention to the details, you can avoid some unpleasant time in the water. Riding waves isn't necessarily the easiest sport to learn, especially if you've got no experience with a surfboard or other surf sports. Your board is your tool, and should become an extension of your body, helping you merge with nature in a way you would never have dared imagine.

Riding your first wave will make you feel as though you are one with your board, with the water and with yourself. Only then will you understand what I mean and how I mean it. And to get to that point you'll need take the following advice to heart

FRAGILE

 FRAGILE HANDLE WITH CARE DO NOT STACK TOPLOAD

HANDLE WITH CARE

 AS FRAGILE AS A RAW EGG

TO ENJOY YOUR BOARD FOR A LONG TIME, MAKE SURE YOUR BABY GETS THE RIGHT KIND OF TLC. DON'T SCRIMP WHEN IT COMES TO PAYING THAT EXTRA BIT FOR A BOARD BAG. THEY'RE AVAILABLE IN VARIOUS FINISHES. STARTING WITH BOARD SOCKS THAT AT LEAST PROTECT YOUR BOARD FROM DIRT. THEN THERE ARE BOARD BAGS WITH VARIOUS DEGREES OF PADDING — THESE ARE INDISPENSIBLE WHEN YOU'RE TRANSPORTING YOUR EQUIPMENT BY CAR OR AEROPLANE. AFTER USE, A FRESH WATER SHOWER WILL DO YOUR BABY GOOD, AS SALT WATER IS DAMAGING.

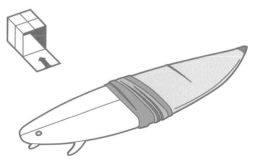

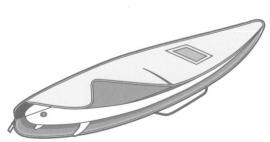

CARRYING COMFORT

TO AVOID ARRIVING TOTALLY EXHAUSTED AT THE BEACH, FIND THE MOST COMFORTABLE WAY TO
CARRY YOUR BOARD. IF YOU'RE STRONG ENOUGH, IT'S BEST TO TUCK THE BOARD UNDER YOUR
ARM AND TRY TO STAY RELAXED. IF YOU'RE THE PROUD OWNER OF A BOARD-BAG, USE IT.
TAKE CARE NOT TO GET IN THE WAY OF OTHERS WHEN YOU'RE CARRYING YOUR BOARD.
ESPECIALLY WHEN IT'S WINDY. LIGHTER BOARDS QUICKLY TAKE ON A LIFE OF THEIR OWN AND
BECOME AIRBORNE. SURFBOARDS ARE VERY FRAGILE AND SHOULD BE HANDLED AND TRANS-
PORTED CAREFULLY

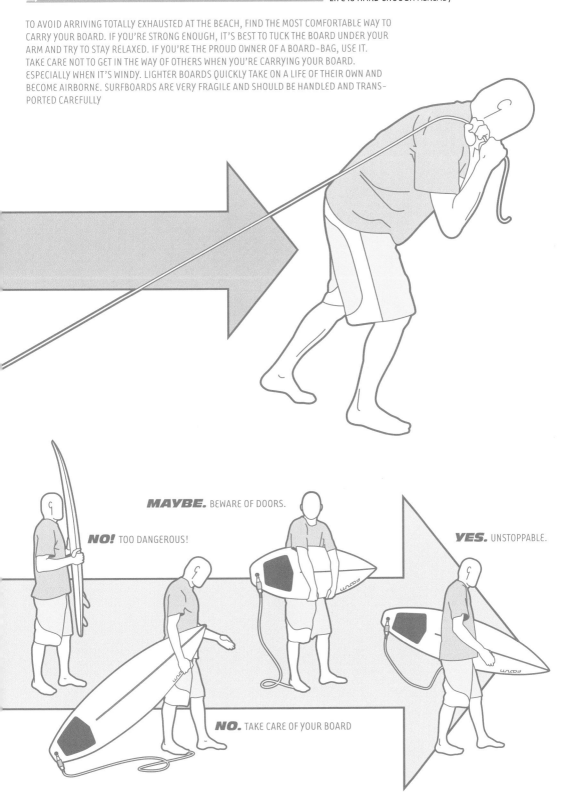

MAYBE. BEWARE OF DOORS.

NO! TOO DANGEROUS!

YES. UNSTOPPABLE.

NO. TAKE CARE OF YOUR BOARD

BOARD PROTECTION

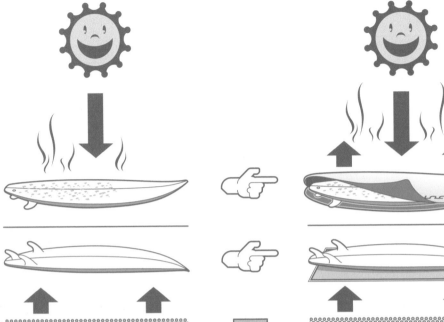

AVOID DIRECT SUNLIGHT ON THE DECK AND DI-
RECT CONTACT BETWEEN SAND AND DECK. IN
BOTH CASES YOU WILL NOT BE HAPPY. WAX BE-
COMES SOFT, MELTS AND SAND STICKS TO IT.

SUPPORT THE SAFEST WAY TO STOW YOUR BABY
IS IN A SUN-REFLECTIVE SHEATH OR STEAL YOUR
GIRL OR BOYFRIEND'S TOWEL TO PUT UNDER-
NEATH IT TO PREVENT CONTACT WITH THE SAND.

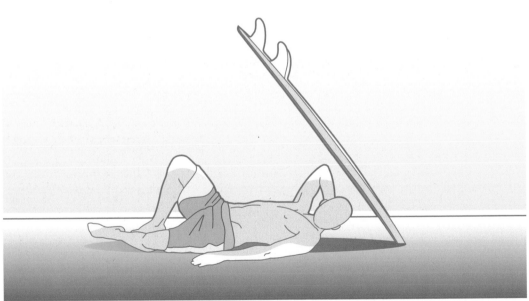

WAXING AND STRIPPING YOUR BOARD

PUT IT ON: IT'S NEVER A BAD IDEA TO GIVE YOUR BOARD A LITTLE OR EVEN MORE WAXING. YOU SHOULD WAX THE UPPER SIDE OF YOUR BOARD USING STRONG CIRCULAR MOVEMENTS, SO THAT A GOOD LAYER OF WAX IS CREATED OVER THE ENTIRE STANDING AREA.

TAKE IT OFF: IN ORDER TO STRIP OFF THE OLD WAX, PLACE THE BOARD DECK-UP IN THE SUN FOR 10-15 MINUTES. AFTER THAT USE THE PLASTIC SCRAPER AT THE BACK OF YOUR WAX COMB AND THE WAX WILL COME OFF EASILY. THEN YOU CAN APPLY FRESH WAX AND YOUR BOARD WILL BE AS GOOD AS NEW...

NIPPLES ON FIRE

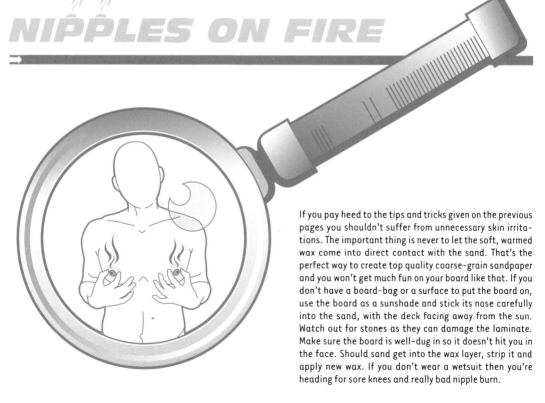

If you pay heed to the tips and tricks given on the previous pages you shouldn't suffer from unnecessary skin irritations. The important thing is never to let the soft, warmed wax come into direct contact with the sand. That's the perfect way to create top quality coarse-grain sandpaper and you won't get much fun on your board like that. If you don't have a board-bag or a surface to put the board on, use the board as a sunshade and stick its nose carefully into the sand, with the deck facing away from the sun. Watch out for stones as they can damage the laminate. Make sure the board is well-dug in so it doesn't hit you in the face. Should sand get into the wax layer, strip it and apply new wax. If you don't wear a wetsuit then you're heading for sore knees and really bad nipple burn.

CHANGING POSITION SHORTBOARD

PUSHING- AND TUBERIDING-AREA - SLOWER SPEED AND FLAT PARTS

CUT-BACK AREA FOR HARD TURNS AND SMOOTH RIDING

POSITION FOR POWERMOVES

CHANGING POSITION LONGBOARD

TRICKAREA FOR STEPPIN' ON THE BOARD - HANG FIVE AND TEN

POSITION FOR LONGBOARD-POWERMOVES

FLOATING AREA FOR SMOOTH TURNS AND FLAT PARTS

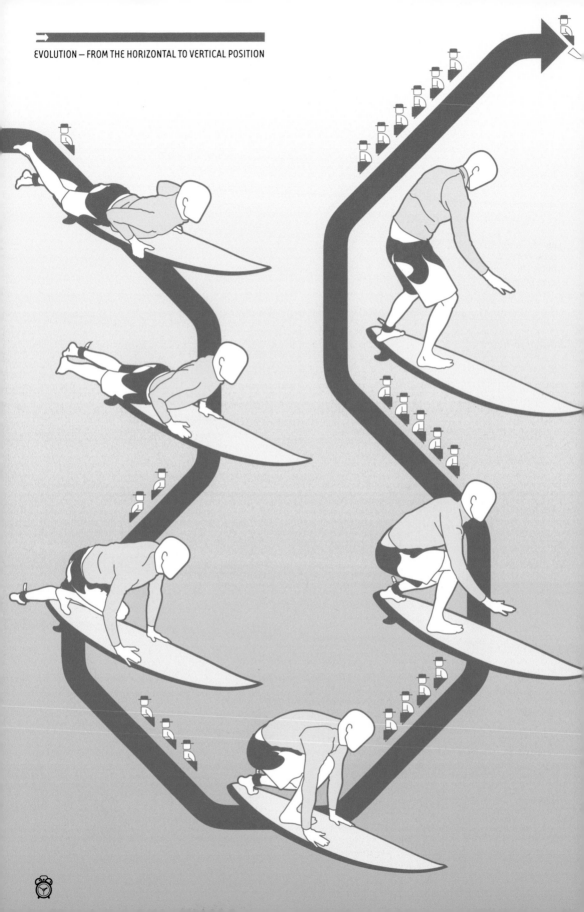

EVOLUTION – FROM THE HORIZONTAL TO VERTICAL POSITION

SANDY STAND-UP

Feel free to get paddling with your feet, so long as you're not on a 9-foot long board and you smash your toes. Get up some speed using one leg and, using your body tension, transfer the force downwards at the back into an upward force. The time factor should not to be ignored when it comes to stand-ups.

Using the speed you've gathered, push down on the board equally with both hands so that you don't curve round. Try to maintain your direction and catapult yourself upwards.

All this has to be done quickly so rehearse and commit the moves to memory. They should become second nature. Now explosively push yourself upwards and position your feet at the same time. You should find you have a secure foothold so you can let go of the board with your hands. That's important!

It's not looking too bad. Try to get a good foothold as quickly and as calmly as possible. If you leave your hands on the board your body weight won't be transferred properly and you'll lose control of the board. This moment is crucial. You need to be able to do it blindfolded.

You can't afford to make any mistakes, although it does depend on the height of the waves. Your feet must be firmly positioned the moment you take your hands off the board and you're standing. Take hands off as fast as possible. As a beginner you should never practise on a short board in open water. Take the same board you'll be taking into the water to practice on dry land. You need to be able to do this move blindfolded before you hit the water.

Up to now everything's gone smoothly. You feel comfortable and are ready to move on. Don't get scared by the speed you may attain. Concentrate and feel how the board connects you to the wave. Every shift of your weight, every twist of your torso will be translated via the board to the water.

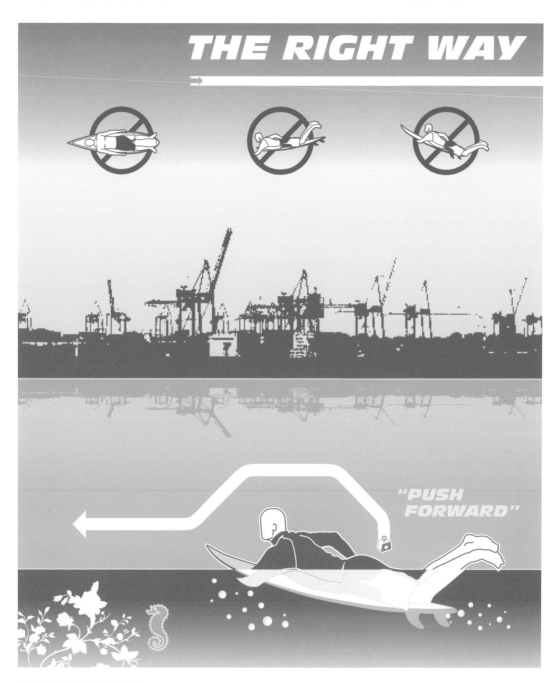

THE RIGHT WAY

"PUSH FORWARD"

NOT TOO FAR BACK AND NOT TOO FAR FORWARD — LET IT RUN AND RUN AND RUN. EVERYTHING FLOWS

Paddling isn't just paddling. You'll realize this at the latest when you're giving your all in the water and suddenly some surfer who knows how to paddle overtakes you without breaking into a sweat. The right technique is just as important as the right position and the best rip. Paddling has nothing, or very little, to do with how you crawl. Body tension is the keyword. Your weight should be concentrated in your pelvis and your arms should pull you smoothly and steadily through the water. Make sure you stay with the current. The nose of the board shouldn't be too high out of the water, but it shouldn't be under the water either. Keep your feet together and, just like a fish, pull forward. Make sure you've got a stable position. Everything will flow.

FEELING AND RHYTHM

IF YOU REST YOU RUST

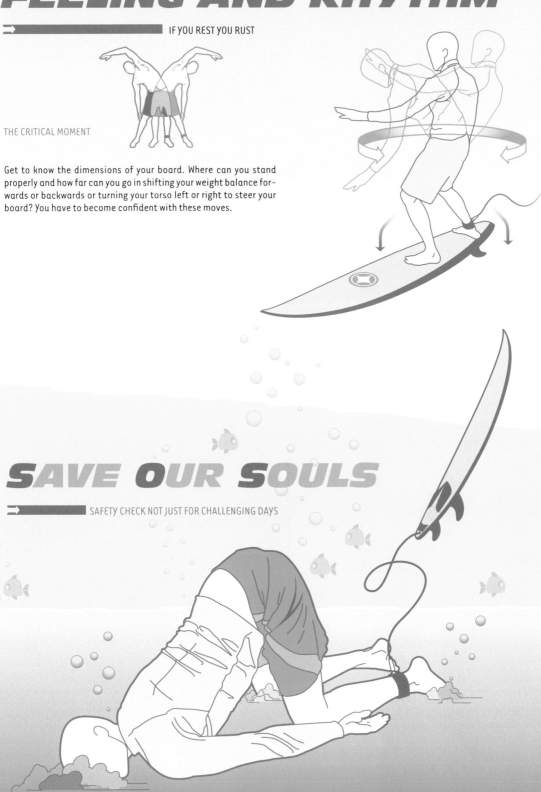

THE CRITICAL MOMENT

Get to know the dimensions of your board. Where can you stand properly and how far can you go in shifting your weight balance forwards or backwards or turning your torso left or right to steer your board? You have to become confident with these moves.

SAVE OUR SOULS

SAFETY CHECK NOT JUST FOR CHALLENGING DAYS

NEVERDO

...*THIS:* Never place the board between yourself and an approaching wave. The board should always be at your side. In every respect...don't leave it in the water unattended, it could injure you or others.

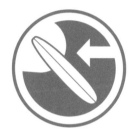

...*AND THIS:* Never, particularly as a beginner, go surfing alone at night. If you do, then only with friends or under supervision. Check the light conditions and orientate yourself by the lights along the coast so that you can gauge the rip.

...*AND THIS:* Choose your wetsuit according to weather conditions. Even if it's "cool", your body will be grateful. Your "little friend" will be too...A warm body can store energy more efficiently and is much less likely to be injured.

...*AND THIS:* Although surfing has a lot to do with feeling, at a certain wave height you should keep a keen eye on the water. Always keep the approaching waves in view, so that you can come further out in good time for an approaching Clean-Up-Set. You won't regret it.

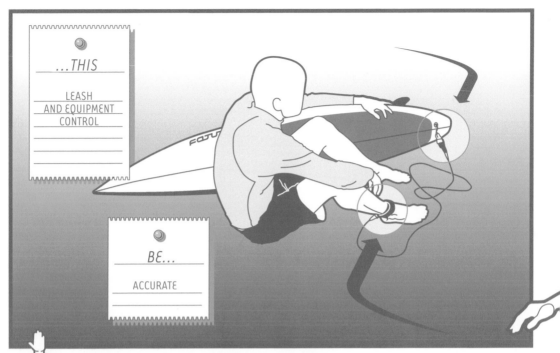

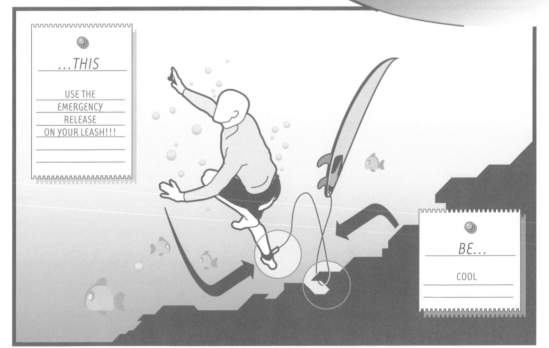

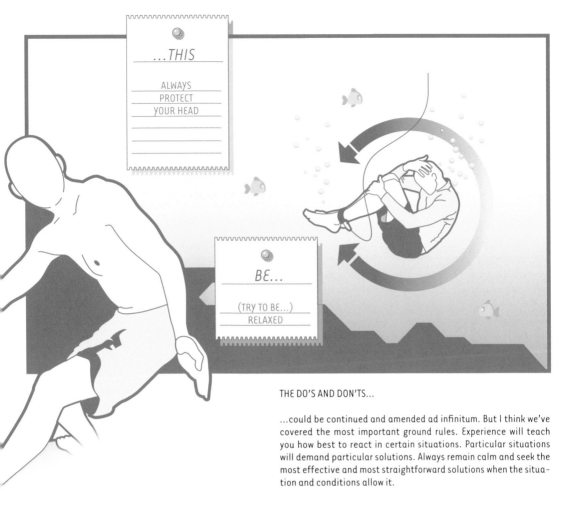

...THIS

ALWAYS
PROTECT
YOUR HEAD

BE...

(TRY TO BE...)
RELAXED

THE DO'S AND DON'TS...

...could be continued and amended ad infinitum. But I think we've covered the most important ground rules. Experience will teach you how best to react in certain situations. Particular situations will demand particular solutions. Always remain calm and seek the most effective and most straightforward solutions when the situation and conditions allow it.

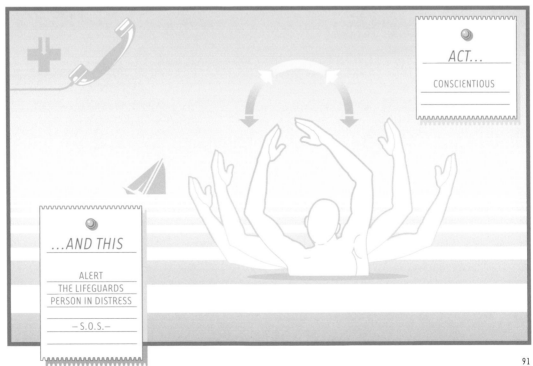

ACT...

CONSCIENTIOUS

...AND THIS

ALERT
THE LIFEGUARDS
PERSON IN DISTRESS

– S.O.S.–

1st AID

THE SMALL LIFESAVER

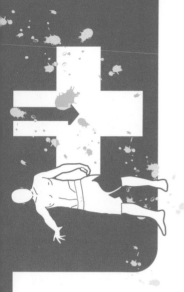

❶ BASICS...

- STAY CALM
- ASSESS, THINK, THEN ACT
- REDUCE RISK OF FURTHER INJURY
- SECURE SCENE OF ACCIDENT
- GET HELP
- EMERGENCY CALL
- DON'T LEAVE INJURED PERSON ALONE

EMERGENCY CALL

WHERE DID WHAT HAPPEN? HOW MANY INJURED? WHAT INJURY? WAIT FOR QUERIES...

TALK TO OR OFFER ASSISTENCE

CONSCIOUS

UNCONSCIOUS

ASSISTENCE ACCORDING TO NECESSITY

CHECK RESPIRATION

NO RESPIRATION

ADEQUATE RESPIRATION

MOUTH-TO-MOUTH RESUSCITATION
PULSE CONTROL AT THE NECK

STABLE RECOVERY POSITION
REPEATED CHECKS
• CONSCIOUSNESS
• RESPIRATION
• CIRCULATION

NO PULSE DISCERNABLE

PULSE DISCERNABLE

HEART AND LUNG REVIVAL

CONTINUATION OF
MOUTH-TO-MOUTH RESUSCITATION

3 APNOEA
(CESSATION OF BREATHING)

ASSESS SITUATION

- NO BREATHING SOUNDS • NO RESPIRATORY MOVEMENT • NO RESPIRATION

 DEATH THROUGH OXYGEN DEFICIENCY

WHAT TO DO

- MOUTH-TO-NOSE RESUSCITATION

IF NOT POSSIBLE

- MOUTH-TO-MOUTH RESUSCITATION

IF NECESSARY

REMOVE FOREIGN OBJECTS FROM MOUTH AND THROAT

CONTINUE RESUSCITATION – PLACE ONE HAND UNDER THE JAW AND GENTLY PUSH THE HEAD BACK AND BREATHE REGULAR STRONG BREATHS INTO THE LUNGS

5 RESCUING PEOPLE

USE A FIREMAN'S LIFT TO GET THEM OUT OF THE DANGER ZONE

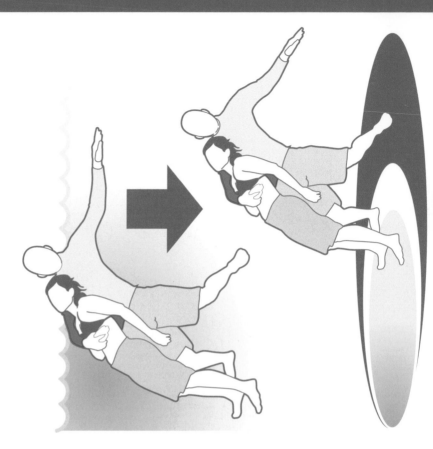

4 CARDIAC ARREST

ASSESS SITUATION

- UNCONSCIOUSNESS · RESPIRATORY APNOEA
- NO PULSE

 DEATH THROUGH OXYGEN DEFICIENCY

WHAT TO DO

CARDIO-PULMONARY RESUSCITATION
LOCATE PRESSURE POINTS
HEART MASSAGE AND
ALTERNATING MOUTH-TO-NOSE
RESUSCITATION 5-8 STRONG
DOWNWARD PRESSES ABOVE
THE HEART, ALTERNATING
WITH 2 - 4 STRONG
BREATHS PRESSURE ON THE
HEART SHOULDN'T BE TOO
WEAK. DON'T BE RETICENT
TO USE FORCE.

PRESSURE POINT

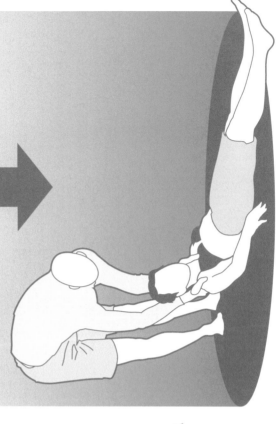

6 SHOCK

ASSESS SITUATION

- RACING AND WEAKENING PULSE, WHICH IS FINALLY ALMOST INDETECTABLE
- PALOR
- COLD SKIN, SHIVERING
- SWEAT ON FOREHEAD
- EXTREME LETHARGY

THESE SYMPTOMS AREN'T ALWAYS PRESENT AND DON'T OCCUR SIMULTANEOUSLY WHAT TO DO

- PUT INDIVIDUAL IN RECOVERY POSITION
- STEM ANY BLOODFLOW
- PROTECT FROM HEAT LOSS
- ENSURE PEACE AND QUIET
- COMFORT INDIVIDUAL BY TALKING CALMLY
- KEEP A CONSTANT CHECK ON CONSCIOUSNESS, RESPIRATION AND CIRCULATION

7 UNCONSCIOUSNESS

ASSESS SITUATION

- AN UNCONSCIOUS PERSON IS NOT CAPABLE OF COMMUNICATION, WHAT TO DO
- ESTABLISH BREATHING

STABLE RECOVERY POSITION

8 BLEEDING WOUNDS

ASSESS SITUATION

BLEEDING WOUNDS CAN BE HIDDEN BY CLOTHING OR BY THE POSITION OF THE INJURED PERSON. DANGERS: SHOCK – BLEEDING TO DEATH (EXSANGUINATION)

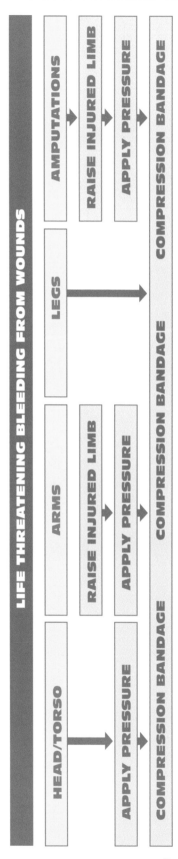

LIFE THREATENING BLEEDING FROM WOUNDS

HEAD/TORSO	ARMS	LEGS	AMPUTATIONS
	RAISE INJURED LIMB		RAISE INJURED LIMB
APPLY PRESSURE	APPLY PRESSURE		APPLY PRESSURE
COMPRESSION BANDAGE	COMPRESSION BANDAGE	COMPRESSION BANDAGE	COMPRESSION BANDAGE

9 BONE BREAKS AND JOINT INJURIES

ACTION Stabilise the injured limb in the position found.

In case of possible injury to spine do not change the injured person's position.

10 SEVERED LIMBS

SEVERED LIMBS SHOULD BE WRAPPED AS FOUND IN STERILE DRESSING MATERIAL WRAP UP AND KEEPING THEM AS COOL AS POSSIBLE, ENSURE THEY ACCOMPANY THE INJURED PERSON.

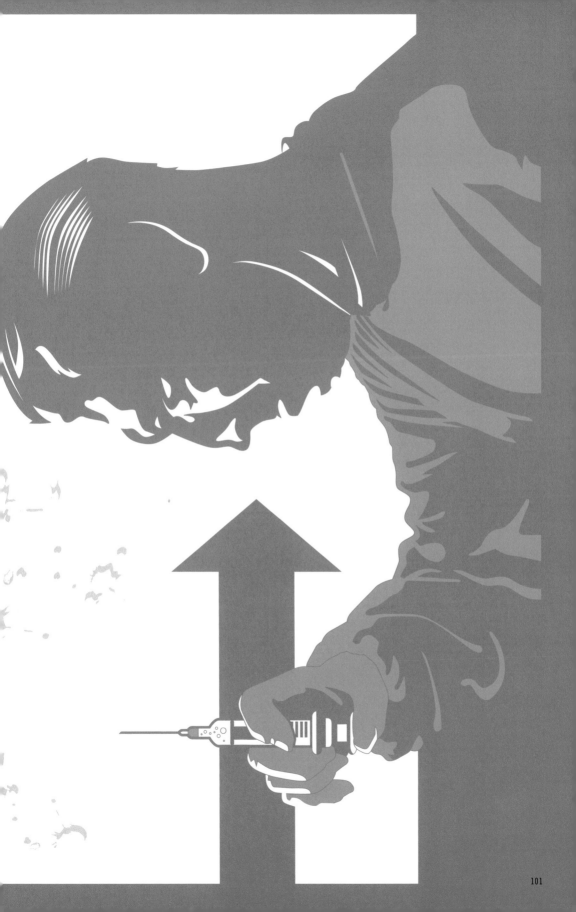

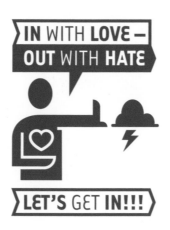

THE GOLDEN RULES
of Surfing

1.
The surfer who waits longest, gets to take the next wave.

2.
The surfer furthest in, closer to the breaking edge, has the right of way. Anything else would be dropping in! The surfer who starts furthest in to the shore has to leave the wave. So when you start, always keep an eye on the break of the wave. Usually the surfer closest to the peak will let you know he's there by shouting "Hep" or "Hey". Paddling around another surfer to get a better position is also termed "snaking".

3.
A surfer already surfing the "green" wave further out, has right of way. These rules often lead to conflict between short and long-boarders because the longies find it easier to catch a wave than those on shortboards. So, long-boarder, make up your mind whether you want to be the asshole who goes by the book and takes every wave, or a good surf brother who lets the shortboarders get a look in too.

4.
If a surfer is on a wave, he has priority over the surfer paddling out to sea. For the paddler it means "into the whitewater, make a deep duck-dive and don't take the easy route. Or you could ruin the other surfer's ride.

5.
If you're a beginner try to find a spot a bit further away from the others. That gives you the chance of practising without causing accidents.

6.
Know your limits and respect the sea! Learn to swim, in case you can't already do so.

7.
Don't take off before or in front of someone who's "caught inside" and is already in enough trouble as it is.

8.
When you paddle out and a big wave is rolling in on you, only abandon your board in absolute emergencies and when no one is around, then dive under.

9.
Respect the "locals" and don't behave like an idiot! That means, work your way in from the margins, don't just plunge in right in front of their noses.

10.
Show respect and goodwill towards nature and your fellow surfers.

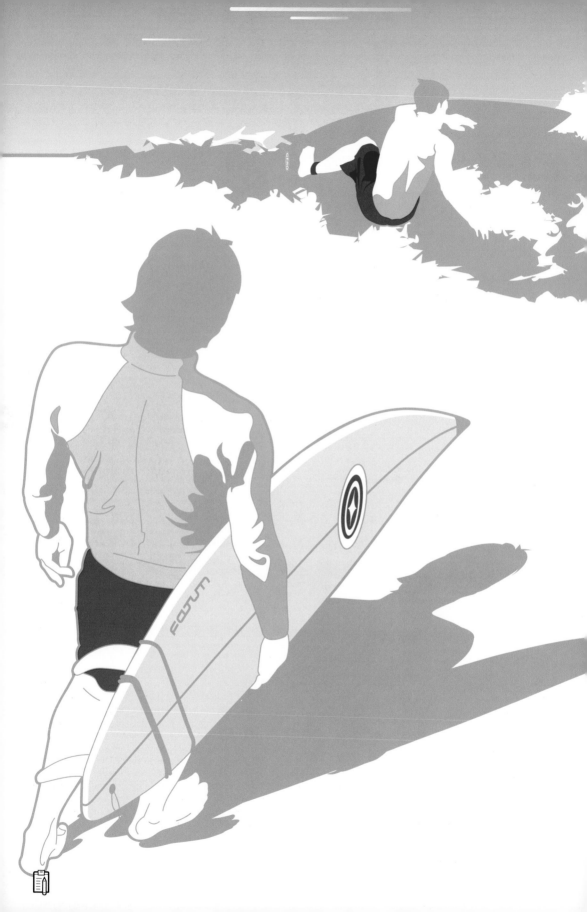

JUST HEAD OUT, DUDE...

SHORT PRE-SURF CHECK

BOARD

SUIT

LEASH

WAX

SPOT

Body and soul are refreshed and the scent of the sea is pulling you beachward. If your abode is a stone's throw from the water it's not a problem if you forget something. But if you have a two-mile hike over the dunes before you, make sure you have all you need for the surf. Check out the situation according to your skill level, and whether you should take a short or longboard.

After your quick warm up you should have the right body temperature, check how cold the water is and decide how long you intend to stay in, then you can choose the kind of wetsuit you need. Check your leash, then another quick wax and you're off. Don't leave your board lying around overnight in the dirt somewhere.
Every board owner should know how to look after his 'baby' and have a padded bag to protect it from inclement weather, especially storms, as the board doesn't weigh much. Perhaps you lent

your board bag to some cute beach girl or boy because the journey home was long and dark, then the wind flipped your board and the wax now feels like coarse-grain sandpaper. Save yourself hassle by scraping off all the wax.
Just lay the board in the sun for ten minutes and the wax will flow like the proverbial wine in ancient Greece. Everything ready? Then you're ready to go. You should be aware of the tides and you should know whether the seabed is sandy and soft or more stony and hard. And whether you'll be swimming with dolphins and seals or with sharks. Check how the currents vary during the day etc... Have fun and catch some good waves.

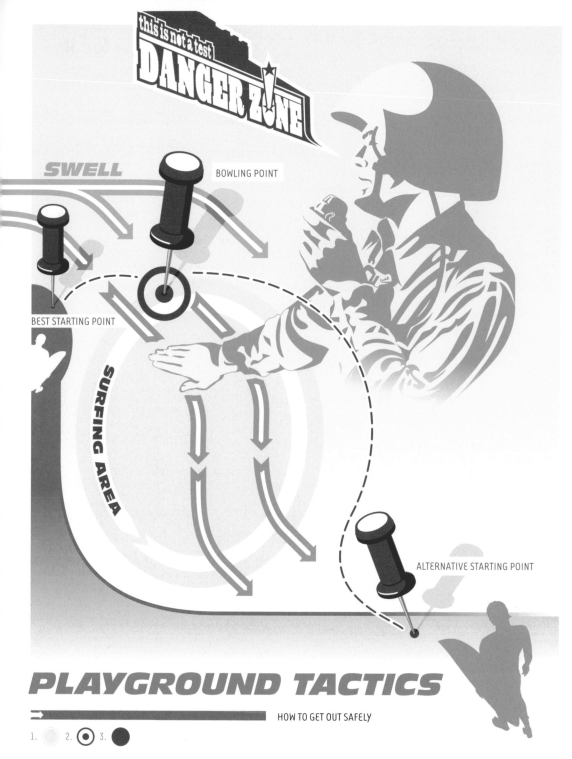

SWELL

BOWLING POINT

BEST STARTING POINT

SURFING AREA

ALTERNATIVE STARTING POINT

PLAYGROUND TACTICS

HOW TO GET OUT SAFELY

1. 2. 3.

1. DANGER ZONE: ONCE THE WAVES ARE A CERTAIN HEIGHT, DON'T TRY TO PADDLE OUT THROUGH THE SURF ZONE. THE BLUE AREA IS THE SO-CALLED IMPACT ZONE. THIS IS WHERE THE WAVES BREAK AND PEOPLE SURF. WHEREVER POSSIBLE STAY OUT OF THIS ZONE.
2. POINT BREAK: WHERE THE WAVE STARTS TO BREAK, IS THE BEST AND MOST POPULAR POINT FROM WHICH TO START YOUR SURF. IT'S ALSO THE SAFEST.
3. TWO POINTS TO START: IN ORDER TO GET THERE WITHOUT GOING THROUGH THE WASHING MACHINE A THOUSAND TIMES, YOU SHOULD CHOOSE ONE OF TWO ROUTES. DEPENDING ON YOUR LOCATION, THE FIRST ROUTE IS PROBABLY FULLY OCCUPIED BY LOCALS. ROUTE No.2 MAY LOOK LONGER BUT, DEPENDING ON THE CURRENT, ISN'T TOO BAD.

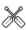

EVERYTHING MUST FLOW

PADDLING ISN'T ALWAYS JUST PADDLING

Depending on how far out in the bay the surf zone is, you should decide beforehand which route to take and whether or not you are fit enough.

The peak is usually clearly visible and if you spend a bit of time observing the water surface you can pinpoint the currents fairly quickly and pick up any other anomalies. Make sure you check this out and adjust your strategy accordingly. Otherwise your day will be ruined and that's not at all what we want. Attach the leash to your back leg, for Goofy to the left one, the rest of us to the right one. Say Hi to the water, the waves and the wind, launch yourself and have fun.

As mentioned in the last chapter, find yourself the optimal position on the surfboard and relax. Don't paddle away as though the devil himself were behind you. Take the first few metres at a relaxed pace because it's going to get harder and longer before it gets easier. That's why you need to conserve your energies. Make sure the tension keeps your upper body upright – this will make it easier to paddle.

Keep your legs together, so that you lie on the board in a streamlined fashion. Try to paddle with a diagonal, overarm action, making elliptical arcs. The further your upper torso is out of the water, the less you will have to overstretch your arms upwards to paddle. Use relaxed, regular strokes and breathe regularly too. Always keep a spare breath while paddling out for the next wave.

SHORTBOARD ▰▰▰ LONGBOARD ▰▰▰ MINIMALIBU

BENEATH THE

THE

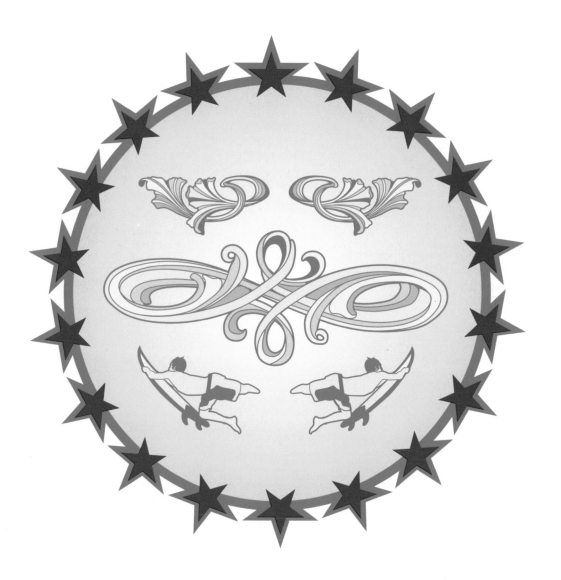

SURFACE

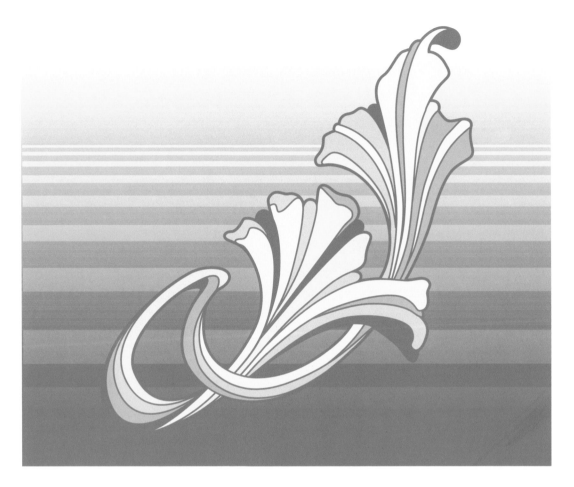

CROSSING WHITEWATER
SO THAT GETTING OUT DOESN'T BECOME A QUESTION OF SURVIVAL.

WHILE SOME PADDLE OUT TOTALLY RELAXED AND IT SOMETIMES SEEMS AS THOUGH THEY ARE SPIRITED OUT THERE BY AN INVISIBLE HAND, OTHERS PADDLE LIKE CRAZY WITHOUT A DOG'S CHANCE IN HELL OF EVER SEEING THE BREAKING WAVES FROM THE OPEN SEA.

After the first few metres you will certainly feel whether the sea is against or with you. Whether the rip is flowing or not. Try to use the many smaller and larger currents in your favour without wearing yourself out. Often there are so-called channels that can help you to get out.

The small foamy rollers that you encounter to begin with shouldn't bring you off course. The whitewater will be more of a bother the closer you come to the surf zone. Here the resistance and pull of the passing waves will become stronger. To avoid trying to maintain position and finding every roller carries you backwards 10 metres, here are some self-help tips.

Important: Always make sure you stay in a streamlined position, whether you're on the surface or under it. It'll save you energy and nerves. Waves are usually, even from a distance, visible or audible. Waves also have a rhythm that you should internalise. If you see a dangerous situation coming, regulate your breathing and for a

short time speed up the frequency in order to be in a position to slice through as straight and as fast as possible.

Just before the wave reaches the nose of your board, take a deep breath, position your hands on the board as if you're about to do a press-up, the width of your shoulders and level with your chest. During the thrust of the wave, raise yourself off the board. Depending on the size of your board kneel on the tail and let the water flow under.

Holding this position for a short time you'll have as little resistance as necessary and the wave won't do you any harm. Once you've reached the most difficult point, try and get moving again as fast as possible.

This is vital, because, gradually, you'll be entering that section where being caught in a press-up position would not be a good idea. If you see a big set of waves coming in, then wait a short while, rather than wasting your energy.

CROSSING WHITEWATER

1 **2** **3**

Even from afar waves are usually clearly audible and visible. Waves also have a kind of rhythm that one should internalise. If a massive wave is nearing, you should remember to breathe regularly and briefly increase your speed and frequency in order to get through the wave as fast and as straight as possible.

Just before the wave reaches the nose of your board, take a deep breath, position your hands on the board as if you're about to do a press-up, the width of your shoulders and level with your chest. During the thrust of the wave, raise yourself off the board. Depending on the size of your board kneel on the tail and let the water flow under.

Holding this position for a short time you'll have as little resistance as necessary and the wave won't do you any harm. Once you've reached the most difficult point, try and get moving again as fast as possible. This is vital, because, gradually, you'll be entering that section where being caught in a press-up position would not be a good idea. If you see a big set of waves coming in, then wait a short while, rather than wasting your energy.

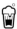

NO BREAK – IF YOU CAN GO STRAIGHT

THE DUCK DIVE

➡ IF POSSIBLE TAKE A DEEP BREATH, CORRECT YOUR POSITION IN RELATION TO THE WAVE AND THEN TRY TO ENTER THE WAVE AS STRAIGHT AS YOU CAN, AS IN A WIND TUNNEL, OFFERING THE LEAST RESISTANCE POSSIBLE.

➡ GRAB THE BOARD AND THROW YOUR WEIGHT FORWARD. PRESS YOUR BOARD DOWNWARDS WITH YOUR ENTIRE BODY WEIGHT AND KEEP YOURSELF STEADY BY USING YOUR KNEE OR FOOT ON THE TAIL-END OF THE BOARD. THE HARDER YOU PRESS INTO THE WAVE, THE STEEPER YOU'LL COME DOWN. YOUR DESCENT WILL ALSO DEPEND SOMEWHAT ON THE VOLUME OF YOUR BOARD AND YOUR BODYWEIGHT. IF YOU RIDE TOO STEEPLY, YOU'LL PRESENT TOO MUCH RESISTANCE AND THE WAVE WILL DRAG YOU ALONG. STAY STREAMLINED.

➡ THE WAVE IS NOW RUNNING OVER YOU AND THE LARGER THE WAVE THE DEEPER YOU SHOULD TRY TO DIVE. THE RED ZONE SHOWS YOU THE AREA THAT COULD GET DANGEROUS. THAT'S WHERE THE SUCTION OF THE WAVE IS STRONGEST. JUST GIVE A GOOD LEG KICK TO PROPEL YOU FORWARD AND SLICE THROUGH THE WAVE.

➡ AFTER A FEW ATTEMPTS YOU'LL GET THE HANG OF STEERING THE BOARD. WHEN THE WORST HAS PASSED OVER YOU, JUST PUT A BIT MORE PRESSURE ON THE TAIL WITH YOUR KNEE AND YOU'LL FIND YOURSELF BACK IN OXYGEN CITY. TRY TO DO THE WHOLE THING AS ONE FLOWING MOVEMENT AND PRESENT THE UNDERWATER CURRENTS WITH AS LITTLE RESISTANCE AS POSSIBLE. THE NEXT WAVE WILL COME FOR SURE AND YOU'LL HAVE PLENTY OF OPPORTUNITIES TO PRACTISE DUCK DIVING. BUT PLEASE START WITH SMALLER WAVES OR TRY IN THE SHALLOWS TO GET A FEEL FOR THE SITUATION UNDERWATER.

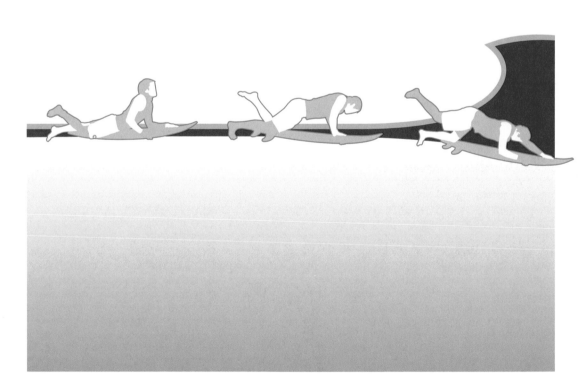

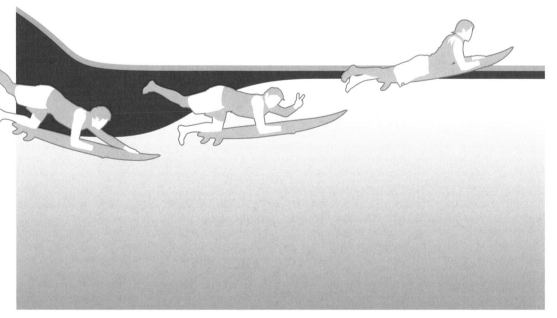

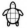

THE TURTLE

➡ BEFORE THE WAVE COMES, REALLY STEP ON THE GAS, TAKE A DEEP BREATH AND, DEPENDING ON THE HEIGHT OF THE WAVE, EXPECT WATER UP YOUR NOSE. BUT ABOVE A CERTAIN WAVE HEIGHT, YOU NEED TO GET OUT OF THE WATER FAST IF YOU'RE ON A LONGBOARD.

➡ JUST BEFORE THE WAVE GETS TO YOU, GRAB THE BOARD AT SHOULDER HEIGHT AND THROW YOURSELF ON YOUR SIDE. THE WHOLE PROCESS SHOULDN'T TAKE TOO LONG. THE IMPORTANT THING IS TO KEEP A GOOD GRIP ON THE BOARD. SHOULD IT GET RIPPED AWAY BY THE SUCTION OF THE WAVE, MAKE SURE YOUR HEAD IS PROTECTED.

➡ YOU'VE JUST DONE A 180° TURN, THE BOARD IS LEASHED AND LYING IN THE WATER LIKE A DRIFT ANCHOR. THAT MEANS, UNLIKE WITH A DUCK-DIVE, YOU'RE PRESENTING MAX. RESISTANCE. SHOULD THE WAVE BE BIGGER THAN YOU THOUGHT, LOSE THE BOARD, DIVE DOWN AND PRAY THAT THE LEASH FULFILLS ITS MAKER'S PROMISE.

➡ WHEN THE WAVE HAS PASSED, DO ANOTHER 180° BACK ONTO THE BOARD AND CONTINUE PADDLING, BECAUSE THE NEXT WAVE WILL BE ON ITS WAY FOR SURE. WITH THE DUCK DIVE AND THE TURNOVER, MAKE SURE YOU ARE AS RIGHT-ANGLED AS POSSIBLE; THAT MEANS HEADING INTO THE WAVE HEAD-ON, AT 90°. OTHERWISE THE FORCE OF THE WAVE CAN'T PASS YOU BY AND IT'LL TAKE YOU WITH IT

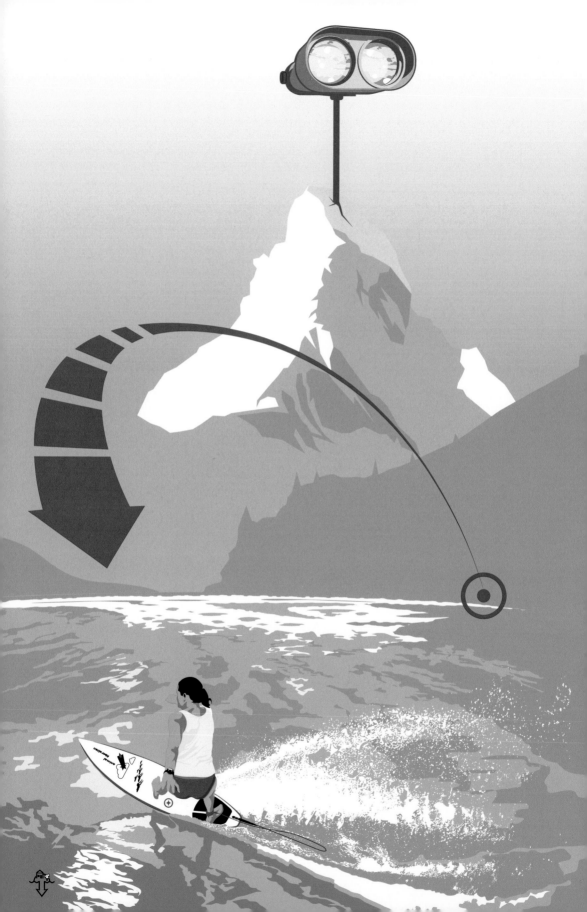

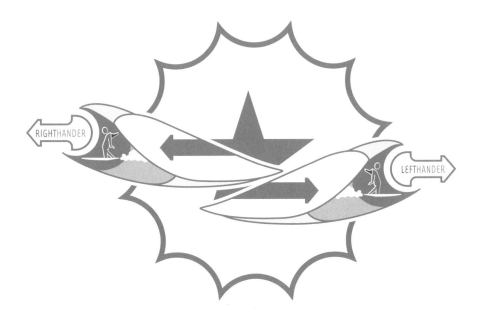

THE OUTSIDERS

INSIDE OUT

Congratulations if, contrary to expectations, you've made it all the way out (only joking!). Hopefully you've carefully rationed your energy and can now look forward to some good surfing. First take a look around and check out how other surfers are behaving, where they start, whether that's a left-handed wave or whether it's better to take it on the right. These are important questions that need answering. To enjoy the luxury of choosing your own starting point you either have to be a local or at least have an intimate relationship with one of them. If neither of the above apply, then there is a clear hierarchy in the water and, especially as a beginner, you'll have to take what you're offered. Anyhow, you don't have to attempt your first waves at a "hot spot".

Look for smaller waves further in so that you don't get in anyone's way and you can practise in peace. Your spot should be next to or at the place where the wave begins to break in one direction. Don't start directly at the apex of this spot, but rather to the left or right of it and wait your chance. If the wave is steep enough and is strong enough, it'll take you. Make sure the wave isn't already breaking but is steep enough to carry you with it and, helped by your own strong paddling, will propel you forwards. From that point on everything has to move fast.

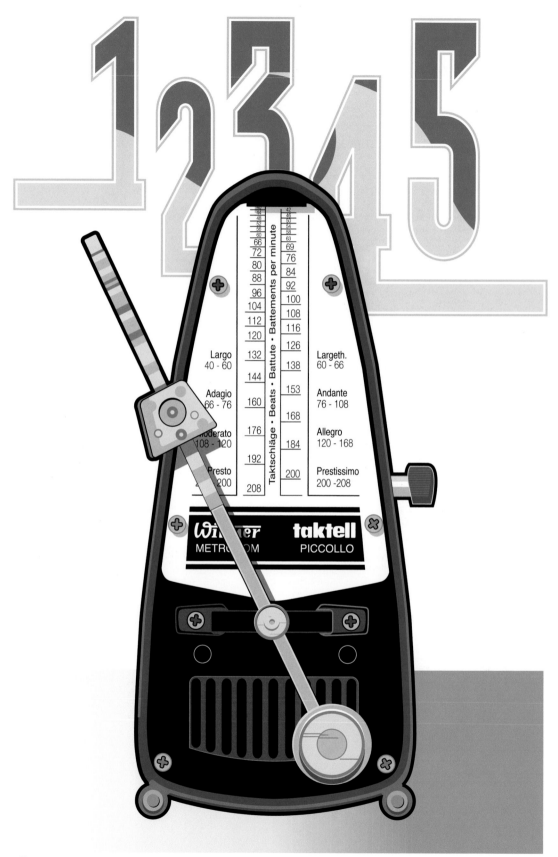
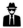

HUNTED BY A FREAK

NOW THINGS GET SERIOUS. ADRENALIN LEVELS RISE THE CLOSER YOUR CHOSEN WAVE GETS; A FEELING OF PANIC GROWS. MAKE SURE YOU'RE WELL POSITIONED AND THAT YOU DON'T HAVE TO PADDLE 20 METRES, BUT ALSO THAT YOU DON'T HANG ABOUT TOO LONG IN THE REALLY STEEP WALL OF THE WAVE. THERE IS ALWAYS ONE POINT IN THE WATER THAT GIVES YOU THE IDEAL AMOUNT OF PUSH AND SUCTION. THAT'S THE POINT YOU SHOULD TRY TO MAKE OUT. IN NATURE EVERYTHING FOLLOWS CYCLES. THE SEASONS, STORMS, RAIN AND WAVES TOO. THEY MAY ROLL UNBROKEN TO THE BEACH BUT THEY HAVE CYCLES TOO. A SET USUALLY COMPRISES THREE TO SEVEN WAVES THAT START OUT SMALL, BECOMING BIGGER TOWARDS THE MIDDLE. MAKE SURE YOU DON'T COME UNSTUCK ON THE FIRST OR SECOND WAVE. TAKE ONE OF THE LAST TWO TO THREE WAVES, SO THAT IF YOU DO TAKE A DUNKING, YOU WON'T HAVE TO COPE WITH SIX MORE "MONSTERS" ROLLING OVER YOU.

IF YOU'RE ON TRACK AND MENTALLY PREPARED YOU SHOULD BE ABLE TO MATCH THE WAVE'S SPEED IN FOUR OR FIVE STROKES. ONCE YOUR BOARD HAS OVERCOME THE SURFACE FRICTION YOU'LL BE ON A ROLL. THIS ALL HAPPENS REALLY QUICKLY FROM THIS POINT ON. I HOPE YOU'VE INTERNALISED THE STAND-UP ROUTINE PRACTISED ON LAND, THAT YOU MANAGE TO STAND AS SOON AS THE BOARD'S RUNNING FREE. PRESS THE WAVE-EDGE INTO THE WATER SO AS TO ESCAPE THE BREAKING PART OF THE WAVE CATCHING UP ON YOU. AND AWAY YOU GO. BON VOYAGE.

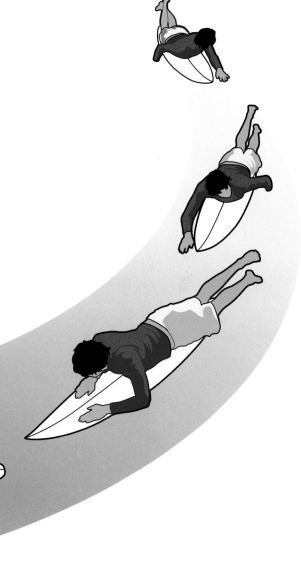

THE GET-UP KIDS

→ TIMING – POSITION – DIRECTION – SPEED

THE BETTER THE STARTING POINT THE EASIER THE STAND-UP

Once you've managed to get out there, you'll no doubt need a few terrible tries before the wave's got you and you manage the stand-up effortlessly. But don't panic. Think before you act and always make sure to save some strength.

Even if the water seems to be moving in an even way, it remains unpredictable. Try, even if this sounds silly, to get into the mindset of the water, feel the water, after all your body is full of it. Sense the rhythm, be alert and feel the unity between you and the water. It may sound crummy now, but when you're in the water, and you realise you're not surfing against the wave but with it, you'll know what I mean.

In any case you should take a good look at the illustration on this page. Not because of the cute dolphins but because of the position the surfer is in. A good place to be is half-surf. Make sure you don't get in anyone's way and you don't block other surfers' right of way or steal someone's wave. Let's go!

Surfer No.1 has definitely been dealt a bad hand. His board will either spike the wave because the wave is too steep already or the wave will break directly on top of him, neither of which is particularly nice. If you notice in time that your position isn't ideal you should always have an emergency break prepared. Sometimes it's enough to set down on the tail briefly, for a quick brake. But often the only emergency exit is to do a TURTLE or take a dive.

Things seem to be looking good for Surfer No.2. From his vantage point he's positioned to the right of the peak and will thus have enough time to concentrate on his stand-up. In this position the wave and the surfer should find each other together and the board should break free. As described previously, a final and strong leg kick will give your body an upward thrust and just as in a powerful press-up, you will launch upward. Don't forget you don't have solid ground under you, so your weight should concentrated at the centre of the board and evenly distributed. Otherwise your board will cut a curve faster than Jamie Oliver cuts his onions.

And no one wants that. The move from horizontal to vertical position should only take a second. The quicker, the better and it will put you in a better position to make a few nice turns. If you have managed that, done a few nice turns or even if you've only surfed straight ahead, you'll no doubt feel that nice warm feeling in your stomach. Now straight back to the peak. Paddle in a relaxed way, as you already should be now doing anyway, and try the whole thing again. Don't paddle directly through the surf. It's not only dangerous but it takes a lot of energy.

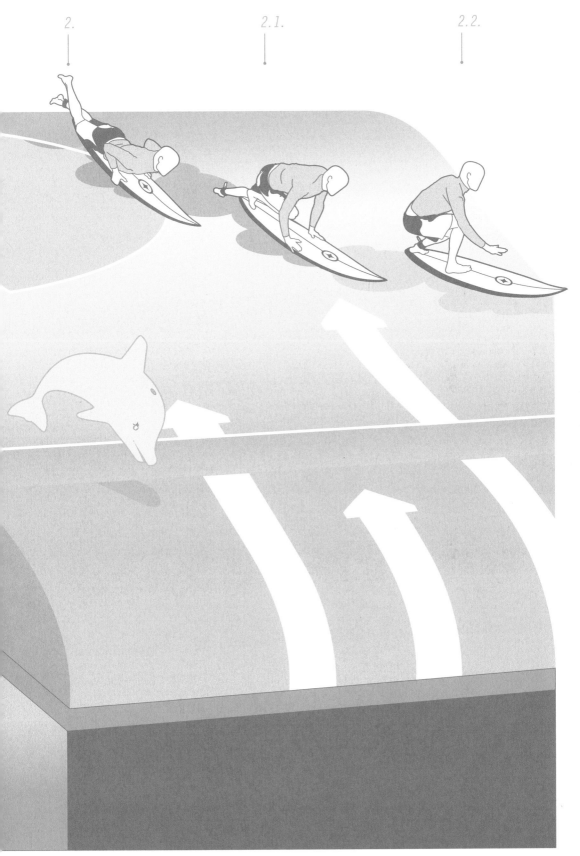

PRELIMINARY MEDICAL EXAMINATION

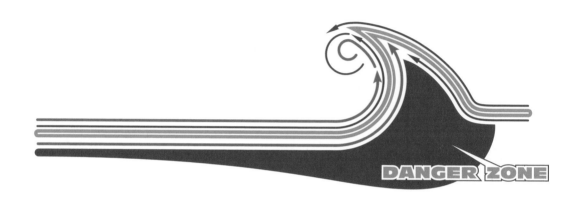

DANGER ZONE

THE WIND KEEP THINGS GOING

Most people who don't live directly near the sea think that waves flow; that they actually move, from point A to B. The truth is that waves are dictated by wind, which propels large volumes of water in one direction, thus creating a kind of chain reaction. Water is a homogenous element that transports energy. Water takes the energy created at its surface and carries it wavelike onward. It doesn't even take a large swell for this to happen; a little wind and a wave impulse to get things going is enough. Kinetic energy. This power is carried onward without energy loss. Waves add to it and carry the energy until the seabed rises and the water becomes shallower.

You can imagine this phenomenon by running a stick under a piece of cloth letting it "flow" like a wave. Water, taken as a whole, is static; it is only the currents within it that move. When this energy hits the beach it is conducted upward. The faster this takes place, i.e. the steeper the seabed rises, then the steeper and higher the wave will be. Water stretches upward and forms a breaking wave.
The following water thus meets a resistance and flows back into the sea, towards the other incoming waves.

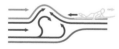
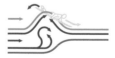

IN THE SMALL ILLUSTRATIONS YOU SHOULD BE ABLE TO SEE THE FOLLOWING: EBBING WATER FLOWS AND HITS THE WATER FLOWING IN THE OPPOSITE DIRECTION. IN ADDITION THE WATER COMING IN IS PUSHED UPWARD DUE TO THE INCREASING SHALLOWNESS. THIS MEANS THAT THE WATER IN FRONT OF THE INCOMING WAVE IS FORCED OUTWARD AND FLOWS TOWARDS THE BEACH BEHIND THE NEXT WAVE. UNDER WATER, THAT IS, UNDER THE WAVE, A KIND OF VORTEX IS CREATED WHICH, WHEN IT REACHES ITS ZENITH, TUMBLES THE WAVE OVER ITSELF. IF YOU WANT TO TAKE A DUCK DIVE, YOU SHOULD TRY TO GET BELOW THE VORTEX, TO AVOID BEING DRAGGED ALONG BY IT. THIS AREA IS MARKED AT THE TOP AS A DANGER ZONE. IF YOU PADDLE TOWARDS THE WAVE, YOU'RE NOT REALLY MOVING FORWARD. BECAUSE ITS EXPANDING SURFACE AND THE CURRENT, IS PULLING WATER BACK. AND WITHOUT PADDLING, YOU WILL BE PULLED BACKWARDS TOWARDS THE WAVE. YOUR AIM IS TO GET YOUR BOARD FREE, SO YOUR FORWARD THRUSTING ENERGY HAS TO BE TRANSFERRED TO THE BOARD TO OVERCOME THE SURFACE TENSION AND OVERCOME THE PULL. THAT'S WHY IT'S IMPORTANT TO LET THE BOARD GO AS SOON AS POSSIBLE, SO THAT AQUAPLANING CAN TAKE PLACE. CLEAR THE ROAD PLEASE...

Have a nice surf

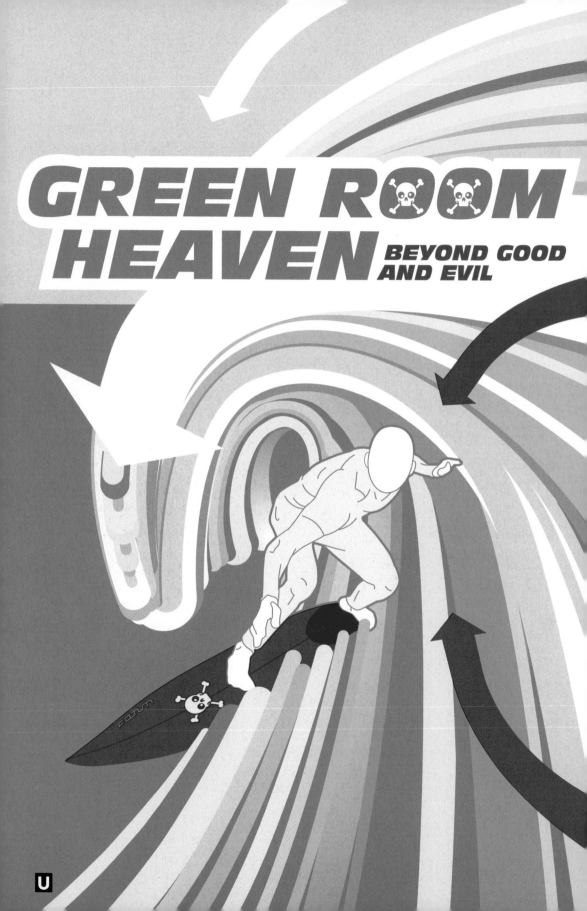

IN THE BARREL

UGLY DUCKLIN'

It's a moment of sudden clarity. The water embraces you, takes you in its arms and the concept of destiny almost loses meaning. You're at one with the sea and only you can take the road that has to be taken. Since Gerry Lopez surfed Banzai Pipeline, the 'green room' has been the surfer's ultimate goal – it provides that wonderful unity between body, soul and nature. Tube riding is the fastest way to win the most respect, but you need to respect the power of the waves too. You also have to be able to gauge the situation and react accordingly at any time. If the tube eats you, your only hope, depending on the size of the wave, is to pray. Even if you're not a religious person, you'll pray. Not necessarily to God, more likely to the sea that will hopefully release you.

More than a few have lost their lives in the most dangerous reef-generated waves on this planet and, sadly, many will do so in the future. Reef breaks generate enormous power and speed, and there's nothing in the world that can save you, except the hope that the ocean loves you and will spit you out again.

On top of it all there is the dangerous bedrock; the shallower the water, the better the tubes. Slamming into the reef bed is no rarity. Lacerations, grazes, dislocations and broken bones are part and parcel of this ultimate challenge.

Avoid reefs if you're a beginner. You really need a lot of experience in order to be able to calculate the risks involved. If you can do it, you'll be one of those luckier people who was allowed to see and experience something that not many will.

The most beautiful tubes on the planet you're ever likely to experience are in Indonesia, on the Maldives, at Pipeline, Hawaii, or in Jeffreys Bay in South Africa.

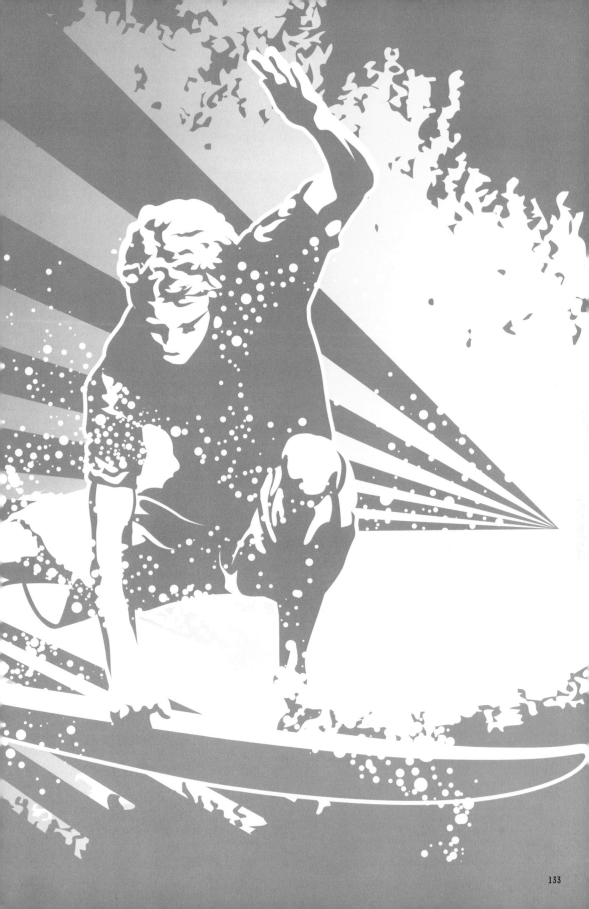

01/7

02/7

04/7

05/7

BIGTRIXxL

DEFYING GRAVITY AND THE LIGHTNESS OF BEING

UP IN THE SKY, SO GOES THE SAYING, THE SWALLOWS FLY HIGH. THE SMALLER, SLIGHTLY MORE BULKY FREESTYLE SHORTBOARDS ENABLE YOU TO REACH HIGH SPEEDS, PARTICULARLY WHEN THE WAVES ARE SMALL AND YOU GET THE CORRECT VOLUME IN THE FRONT THIRD OF THE BOARD AND ALONG THE EDGES, ALLOWING THE BOARD TO RIDE WELL. IT GETS GOING QUITE QUICKLY AND DUE TO THE GREATER VOLUME YOU CAN LAUNCH YOURSELF 'OFF THE LIP' NICELY. THE BOARDS ARE EXTREMELY MANOEUVRABLE AND CAN TAKE A LOT OF PRESSURE ON THE TAIL, LETTING YOU SKIN YOUR BUTT. IT'S ACTUALLY THE BEST COMBINATION BETWEEN SKATING AND SNOWBOARDING SO TRICKS CAN BE ADAPTED TO EACH SPORT.

What an amazing thing. Surfing as a sport has changed so radically in the last few years, at least as far as the technicalities of the game are concerned. So nowadays, pretty much anything is possible. Just as it was impossible to imagine Kelly Slater's comeback, and then the boy puts down a rodeo at the BILLABONG PRO in Jeffreys Bay (South Africa) that would wipe anyone out, himself included. But that's by the by.

03/7

06/7

07/7

NICE STYLE SURFING

A lot has changed since the first 'hot-dog' surfing and the first tube or perhaps the first aerial.

Sometimes I think, video game consoles were first, where you got to do all these wild tricks that would've been unthinkable on water. Now a 360° turn is pretty much standard from a certain level on. The sports of surfing, skateboarding or snowboarding have advanced very rapidly from a technical point of view.

Nevertheless, you wouldn't gain as much respect with a nice aerial as you would with a stylish, juicy tube ride.

But that shouldn't tarnish the image of a freestyle surfer in any way. Anything goes these days and another door is always being opened, bringing new possibilities, ideas and developments. Surfing is progressing constantly and will be continually born anew from within itself.

STYLE POLICE

~ *to surf and protect* ~

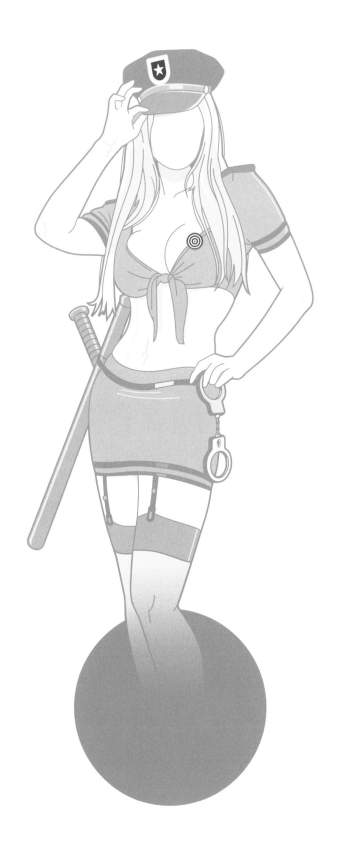

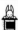

BIG WAVE ZONE
nice waves' home

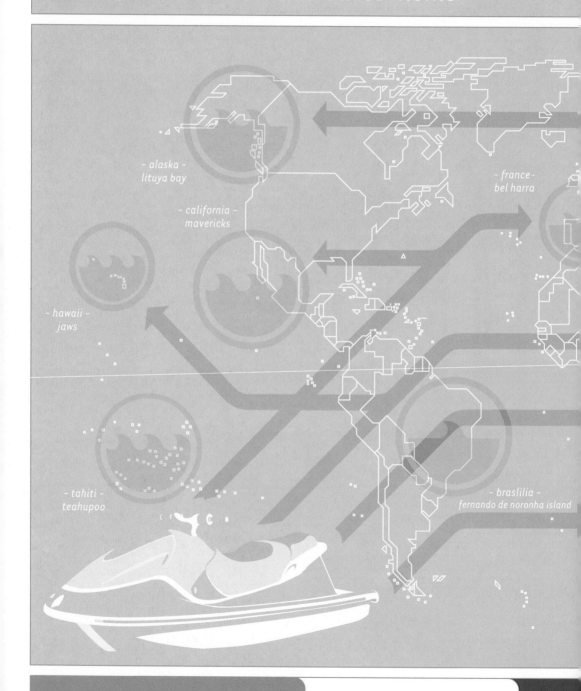

- alaska -
lituya bay

- california -
mavericks

- france -
bel harra

- hawaii -
jaws

- tahiti -
teahupoo

- braslilia -
fernando de noronha island

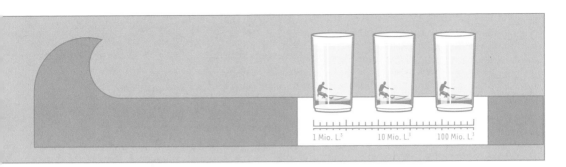

1 Mio. L.³ 10 Mio. L.³ 100 Mio. L.³

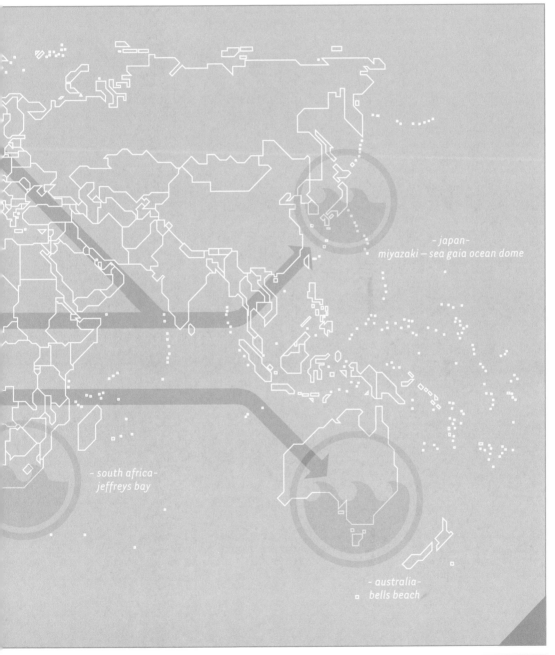

- japan -
miyazaki – sea gaia ocean dome

- south africa -
jeffreys bay

- australia -
bells beach

➡ PAIN IS WEAKNESS LEAVING THE BODY

Now we're getting down to it. Only recently has big wave surfing hit the headlines even though it has a long tradition. The desire to surf ever-larger waves has always been an important part of mental and physical progress. Eight metres was the limit of what was surfable forty years ago, when Greg Noll, Owl Chapman und Mark Richards surfed the gigantic waves of Waimea Beach, Makaha and Third Reef Pipeline. There were setbacks too, like the unexpected death of Mark Foo in Mavericks on 23 December in 1994.

Eight metres seemed to be the limit on what was possible using your own strength, due to the speed of the wave and the speed with which wind and water moved up the wall of the wave, and how quickly gravity pulled the surfer down into the valley of the wave.

Using strapboards you would normally be towed into the wave with the help of a jet-ski — this enables you to reach the necessary speed to surf the wave before it becomes too steep. The choice of wave should be carefully considered, as at these speeds it can quickly become too late for a last-minute emergency exit. The straps enable the surfer to surf or ride over smaller, choppy waves. Without straps, a surfer would be knocked off the surfboard by the high speed.

It's hard for someone who will never experience what massive forces you are up against, to imagine what it's like when you get caught by a monster, and how small a human being really is. If you have a wipe out, consider that a new wave comes every thirty seconds (at least that's the case at Jaws, Hawaii). The wave will probably pull you down 10 to 17 metres under the water. In those 30 seconds you'll have the chance to swim up 10 metres and grab a breath of air before the next waves comes. The odds of you getting out of that safe and sound are hardly in your favour, and only a few are physically, psychologically and surf-technically in a fit state to ride such waves. Often your only chance will be a jet-ski rescue.

Every surfer has a partner on a jet-ski for days like these. They work as a team and the jet-ski driver will stay as close as possible to his buddy. That means he drives behind the surfer on the back of the wave in order to get to the downed surfer as fast as possible. No one can predict the size of the waves that will be surfed in the future. But one thing is for sure, the risks involved will not diminish.

IT IS DIFFICULT TO IMAGINE THE AMOUNT OF WATER WE'RE TALKING ABOUT WITH WAVES THIS SIZE. BUT WITH A WAVE BETWEEN 15 AND 20 METRES HIGH IT'S KIND OF LIKE SWEET JESUS (ALTHOUGH IN THAT CASE HE WOULDN'T BE SO SWEET) EMPTYING THE CONTENTS OF A 300 METRE LONG SWIMMING POOL OVER YOU. CHEERS THEN…

And that's without mentioning the 500 metre-high wave that hit the Japanese coast in 1958 due to an underwater quake. This is a prime example of how discharged energy is transformed from kinetic to potential energy. You can find more details and information on this tsunami on the World Wide Web.

INHUMAN

➡ SMALL PEOPLE ON BIG WAVES

WHEN THESE PEOPLE GO OUT THERE, THERE IS NOTHING AND NO ONE WHO COULD HELP THEM. IT'S A QUESTION OF BRAIN-POWER, SURVIVING THIS SITUATION AND IT RESULTING IN A HAPPY ENDING.

It was the windsurfers who started strap boarding. Laird Hamilton, Buzzy Kerbox and Derrick Doerner began being towed into the waves, beyond the reefs on Hawaii's North Shore. Until then it was only windsurfers like Robby Naish or Robby Seeger from Germany, who, driven by the wind, reached the higher speeds necessary for the enormous waves. Offshore from Maui, Jaws was discovered, one of the Big Wave surf spots where Pete Cabrina surfed the highest wave ever (officially recorded) in January of this year. The wave was around 70 ft, that's the equivalent of 21,3 metres. For a while now, Billabong has been hosting the BILLABONG XXL Surf contest. It runs for a year, and whenever and wherever on the planet big waves are expected, attempts are made to surf the biggest wave. 1000 Dollars per foot is the prize money at the end of the year for the biggest wave surfed.

In any case, Mike Waltze, Dave Kalama, Rush Randle, Josh and Mark Angulo as well as Pete Cabrina began surfing the spot. Jaws became something like a new Waimea and Mecca for the big-wave surfers in the whole world. This year the Billabong Contest is going for the 30-metre wave. A million dollars for 100 feet of water. Hang loose.

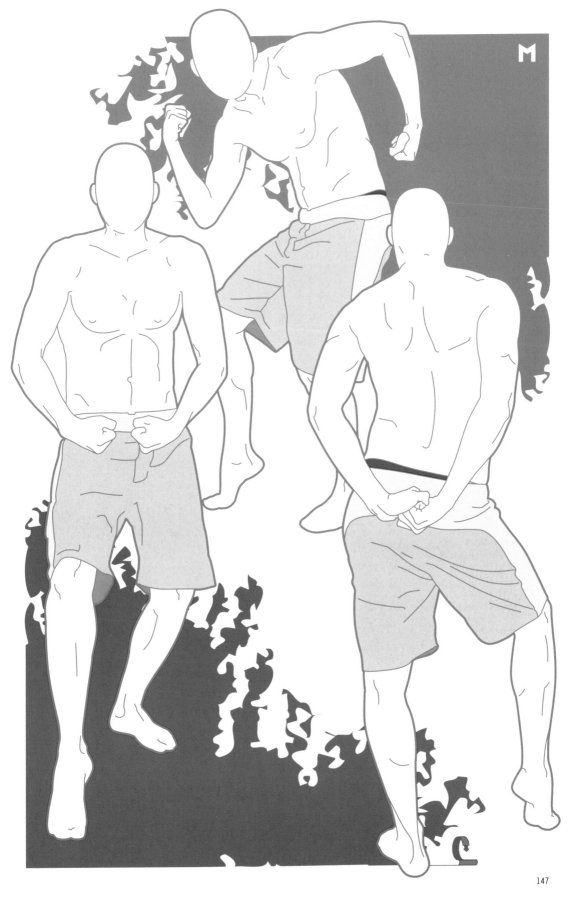

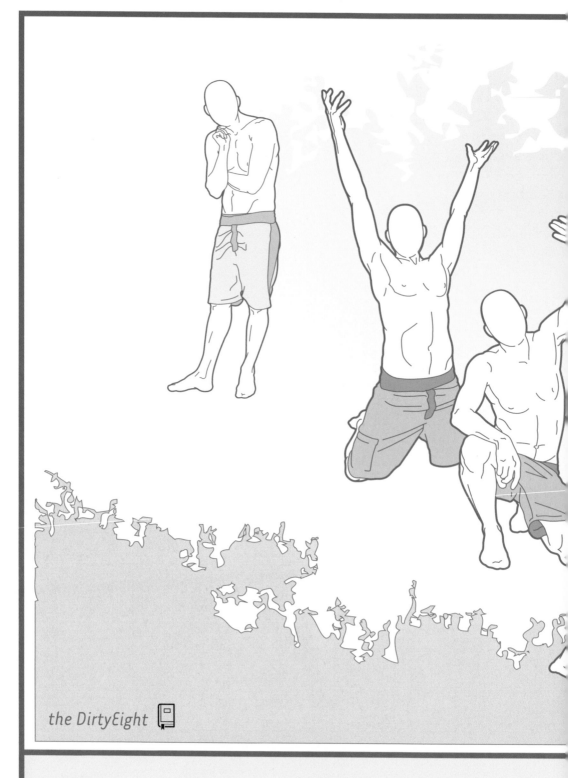

the DirtyEight

Lisa Anderson
-
(March 8, 1969 –)

Gerry Lopez
-
(November 7, 1948 –)

Kelly Slater
-
(February 11, 1972 –)

Tom Carroll
-
(November 26, 1961 –)

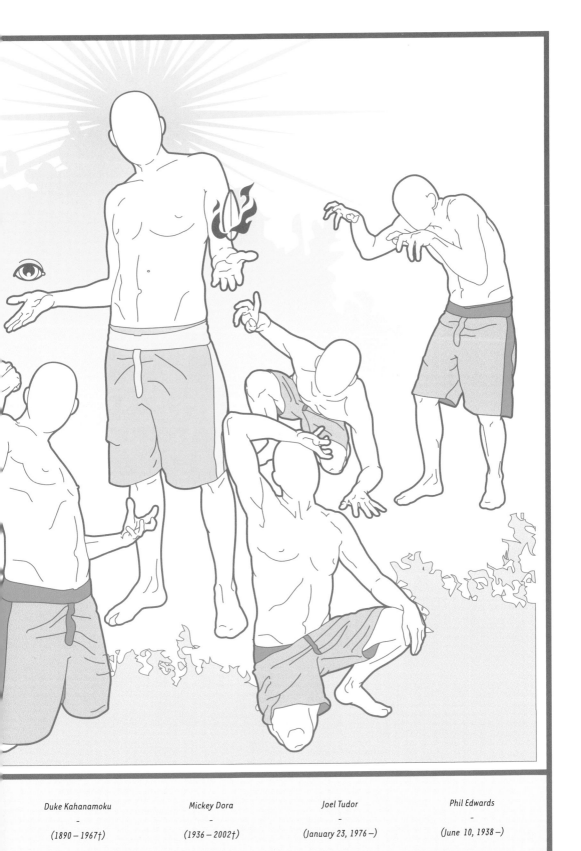

Duke Kahanamoku
-
(1890 – 1967†)

Mickey Dora
-
(1936 – 2002†)

Joel Tudor
-
(January 23, 1976 –)

Phil Edwards
-
(June 10, 1938 –)

360° A very difficult figure in which a complete 360° turn is made. Also called a spin. //: 360er 180 AIR The board is popped out of the water and, with your body in the same position, you turn through 180°. **A** ALOHA Literally, "alo" means "experience" and "ha" means "breath of life". Nowadays it's used to mean "Hallo", "Goodbye", "Love" or "Friendship". AERIAL Part of a manoeuvre where the surfer together with his/her board leaves the water. This manoeuvre requires split second timing and is only performed by expert surfers. **B** BACKHAND //: BACKSIDE Surfing with your back to the wave. BACKWASH On steep beaches, where strongly ebbing water meeting breaking waves (SHORE BREAK) churns up sand and pebbles. BAGGIES Loose-fitting shorts. BAIL-OUT Just before a WIPE-OUT when you want to leave your board and you jump off BARREL Wave tube, the Green Room BEACHBREAK Waves that break on sandy ground. They are pretty safe and good for beginners. The waves aren't as clean as at a //: REEFBREAK and paddling out is often harder and more chaotic. The seabed varies and dangerous RIP CURRENTS can occur. //: SHORE-BREAK BLANK The foam core used in the manufacture of surfboards. (Polystyrene)//: SHAPING BLOWN OUT Winds blowing so hard that they chop up the surf and render it unrideable. BOTTOM-TURN A turn in the valley of the wave in order to do a CUT BACK on top of the wave. BOTTOM Underside, the bottom of the SURFBOARD. BREAK ZONE That's the place, along a line, where the waves begin to break. Behind that is the LINE UP. **C** CURL The constantly shifting boundary between the WHITE WATER, the foam lips, caused by a wave breaking in one or two directions and the GREEN WATER which lies outside the breaking part of the wave, and appears green because of the small air bubbles rising to the surface. Skilled surfers will try to surf in the green part of the wave and as close as possible to the breaking edge. CARVING A softly taken turn. CHANNEL Relatively calm area between two SPOTS (or PEAKS) Ideal for paddling out. Usually a current helps to pull you out. CHANNELS Concave channels on the underside of the surfboard to create lift. Better gliding, higher manoeuvrability //: CONCAVE CHOPPY Water that's whipped up by the wind. Bad surfing. (Opposite: //: GLASSY) CHOPPY WAVES Many "mini-waves" formed usually by bad weather and/or wind which makes the surface unsettled. Chaotic waves. Opposite of GLASSY //:CHOPPY-CLEAN-UP-SET Unusually big SET that breaks outside of the line-up and dumps on the entire line-up. CLOSE-OUT Wave that breaks simultaneously along its whole length. COEFFICIENT (French, masc.) In France they use metric measurements between 25 and 115 that give information on tide levels. CONCAVE Concave channels on the underside of the surfboard to create lift. Better gliding, higher manoeuvrability. CHOPPY Wind that blows roughly parallel to the wave and thus creates small choppy waves on the surface between wave and wave wall. Not good for surfing. CURL //:BREAKING EDGE CUSTOM-BOARD A board that is custom made. //: CUSTOM-SHAPE CUT-BACK Hard curve/turn on the wave's lip, returning to the wave valley to reach a steeper part of the wave. Usually followed by a BOTTOM-TURN. **D** DECK Top of the surfboard. DELAMINATION Damage caused when part of the LAMINATE comes off the surfboard. DING Damage to a board. DRIVING or TIC-TACKING Riding along the unbroken wave wall to the right or left, to get some speed up. DROP

IN To snake someone; or cut in on their wave. DUCK-DIVE For advanced shortboarders who can dive through a wave with their boards by pushing the board down with their body weight. Needs good timing and a good sense of balance. **E** EBB The time between HIGH TIDE until LOW TIDE when the water flows. Usually around 6 hours and 12.5 minutes. //: TIDE TABLE EMERGENCY BRAKE The board is pressed underwater by sitting with your back to the wave and in this way you make it behave like a drift anchor, preventing you being quickly swept away. For instance, while taking a short break when you are paddling out or when you're in the open, awaiting the next set. Diving under, pushing the tail-end down can also be used as an emergency brake, to stop you in full ride and enable you to dive into the Tube. Also called STALL. EPOXY RESIN Artificial resin that is harder and less brittle than polyester resin and can be used to laminate blanks of polystyrene foam. Disadvantages are, apart from the fact that it is more pricey, that it takes longer to harden (in terms of repairs, not very useful) and it is also very toxic (cancer-causing) for the user. ESKIMO-ROLL Technique for diving through waves and to be used particularly where the waves are high and hollow-breaking, when you go out with a small Malibu or longboard. Using this technique, your body hangs under the board with your back to the wave; your hands grip the NOSE or bow section of the board. //:TURTLE **F** FACE Unbroken part of the wave; wave wall. FADE Start (TAKE-OFF) in the direction of the CURL. FINs Fin-like 'stabilisers' on the underside of your board, if you haven't already sawn the troublesome things off. FLAT Flat, unmoving sea without waves, or the powerless section of a wave. FLOATER You pitch yourself with your board onto the breaking part of the wave, like in a 50/50 grind, and let yourself be pulled along. The aim is to have as long and stylish a float as possible. **G** GFK Fibreglass hardener. Made up of fibreglass material and artificial resin. For the artificial resin, use either POLYESTER or EPOXY RESIN. GLASSY A smooth water surface between the waves, resulting from wind-still conditions or a soft offshore breeze. Good surfing conditions, because the wave wall itself will also be smooth. Opposite //: CHOPPY GOOFY-FOOT A surfer who stands with his/her left foot behind. GROUNDSWELL Long, fast waves, relatively low in height, that, under ideal conditions, run the length of the horizon. These make the best waves for surfing when they reach the shoreline, the coast or shallower water. Groundswell happens when WINDSEA leaves the spot where it was created and takes on a stable existence. GUN An extra-long short board for use in high or very high wave conditions. High speed and optimal directional stability. **H** HANG-FIVE Technique, by which a foot is placed over the NOSE with the toes hanging over. Common position when using longboards. HANG-TEN LONGBOARD-EVERGREEN, in which both feet (ten toes) are placed on the NOSE. HANG-LOOSE Surf-

er's greeting. HAOLE The arrival of foreigners (the white man) on Hawaii and the handshake as a greeting ritual brought us the word: "ha _ole", roughly meaning without the breath of life, alien, white man and today on Hawaii it signifies a non-indigenous surfer. HERPES SIMPLEX When wave riding the effects of the sun's ultra-violet rays together with salt water often provokes a virus infection whose main symptom is blistering on the lips. Prevention: protect your lips with a zinc-based cream. Remedy: e.g. use LOMAHERPAN/ ZOVIRAX/ BLISTEZE HIGH TIDE Interval time between ebb and flood – high water mark. //: TIDE TABLE HOT-DOG BOARD In the 1930s boards were developed that at last made it possible to surf right through the waves and no longer broke out so easily. This was achieved by using a narrower bow. They ran faster and were particularly suitable for big waves. HOT-DOGGING Spectacular surf style that grew out of the development of the HOT-DOG-BOARDS. HOULE (French. fem.) //: GROUNDSWELL. **I** IMPACT ZONE The area where the waves break and run out. This area should not be used to paddle out or for swimming practice. INSIDE The space between the BREAK LINE and the shore. From the first BREAK LINE as seen from the shore, a second one, further out (OUTSIDE) follows. Surfers are INSIDE when they are in a TUBE. (Opposite: //: OUTSIDE) **K** KICK-OUT Leaving the wave by using a quite forceful turn of the board over the comb of the wave. KOOK Beginner, inexperienced surfer. Often used as an expression of abuse. **L** LAMINATE Outer skin of the surfboard, made of resin-hardened fibreglass (GFK) LAY-BACK Leaning with one's back onto the wall of the wave to brake the ride. Is often done to allow a TUBE to catch up in order to enter it. LEASH A security line attached to

your ankle and to the board, to help avoid having to swim and retrieve the board after every fall. But the board can hit back. Careful! LEFTHANDER //: LEFT-BREAKING WAVE LINE-UP 1. //: BREAK LINE 2. German Surfing Association Magazine LEFT-BREAKING WAVE Wave that breaks to the left, as seen from a seaward viewpoint. LIP Upper part of the breaking wave edge. LOCAL Local surfer, surfing on his home patch. LONGBOARD Surfboard of a length of more than approx. 2.60m and which usually has a round NOSE. With a LONGBOARD you can paddle out to the waves quite early as it starts sliding relatively quickly. That's why it can be used in very small as well as in high waves. However, DIVE-THROUGH TECHNIQUES are virtually impossible using a longboard because of its large volume. LYCRA (french. masc.) Short or long-armed jacket which is worn in the first instance as protection from the sun. //: WET-SHIRT **M** MALIBU 1. A famous beach and surfing centre in southern California 2. A form of surfboard commonly used in the fifties and sixties. It's similar to the longboard, but with a 7-10 feet length, originally made of balsa wood. MID-TIDE The mid-point between LOW TIDE and HIGH TIDE. MINI MALIBU Surfboard based on the Malibu shape, whose length lies between that of a SHORTBOARD and a LONG-BOARD (approx. 2"2' to 2"6'). **N** NATURAL FOOT/REGULAR FOOT A surfer who stands with his/her right foot behind. LOW TIDE The point between high and low water when the water level is at its lowest.//: TIDE //: TIDE TABLE NEAP

TIDE When the TIDAL PULL is below average at full moon. NOSE The pointed, front end of the surfboard NOSERIDER A LONGBOARD that permits long rides on the board's nose due to the special shape of the underside of its nose section. (CADILLAC) //: HANG FIVE OFF-SHORE Seaward wind. Slows up the breaking of the waves, thus building up steep waves that then usually break hollow. Good surfing conditions. (Opposite //: ON-SHORE) **O** OFF-THE-LIP Out of the wave – into the wave. //: RE-ENTRY OLLIE Jumping over choppy wavelets within the wave, similar to skateboarding. ON-SHORE Wind from seaward. Speeds up the breaking of the waves and often induces 'unclean' breaks i.e. they subside without becoming steep. Not good surfing conditions. (Opposite //: OFF-SHORE) OUTSIDE 1. The space behind a line of breakers (as viewed from the shore). 2. Second (sometimes third) line of breakers further out. (Opposite //: INSIDE) OVER THE FALLS To be ripped along by a falling wave. **P** PAD Foam-rubber mat that is glued to the rear end of the standing area preventing slipping. Usually for the back leg only, to give better grip and allowing you to put more pressure on the tail end. Similar function: //: WAX PEAK Highest, often sharp-pointed part of an in-coming wave, at the beginning of the break, As a rule it indicates a clean-breaking wave. PIN-TAIL Tail end tapering to a point. PLANK Jargon for a surfboard. PLUG The in-built anchor point on the board for the LEASH. POCKET Hollow part of the wave, formed by the LIP. POINTBREAK A wave that turns around a spit of land or a bay and then breaks along the coast. Advantage: constant, clean, long waves, easy to get out to. Disadvantage: danger of being injured by the usually rocky seabed. POLYESTER RESIN Artificial resin which, in contrast to EPOXY RESIN is more brittle and liable to knock-damage. It cannot be used to LAMINATE BLANKs of polystyrene foam because the two components, when mixed, develop a high temperature and can eat into the foam and fuse with it. Advantages are, apart from its lower cost, the short hardening time as well as its low toxicity. POP-OUT A plastic board manufactured by a foam extrusion method; very robust and, thanks to their mass production, cheaper than CUSTOM BOARDS. PULL-OUT Leaving the unbroken wave by making a curve over the crest of the wave. **R** RAILS Raised edges on the surfboard RADICAL /RAD Especially spectacular, "radical". REEF BREAK A wave breaking over a reef of rock, volcanic rock or coral. Very constant and usually hollow-breaking. Because of the seabed, there is a danger of injury and that's why reef breaks are not for beginners. Also, because of their power and speed they are not easy to surf. RIGHT BREAKING WAVE A wave that breaks to the right, as seen from seaward. RE-ENTRY AERIAL with a following re-entry on the lip. REGULAR-FOOT //: NATURAL-FOOT RHINO-CHASER Long GUN, on which enormous waves can be ridden. RIGHT-HANDER //: RIGHT-BREAKING WAVE RIP CURRENT Strong, very dangerous current flowing at first from the BREAK LINE out into the open sea. ROCKER Curve of the surfboard along its whole length (seen from the side). ROLLERCOASTER A term used particularly in France, meaning a smooth, round TURN. ROUND-TAIL A rounded tail end. SHOULDER Shallow, still uninterrupted part of the wave (immediately after the CURL). ROCKER Upward curve of the NOSE to prevent it digging into the water. **S** SECRET SPOT A good spot for surfing, known to only a few. SECTION The breaking part of a wave that time and again breaks in a particular way, e.g. soft and slow breaking SECTION; rapid and hollow-breaking SECTION. SET Regularly appearing group of relatively high waves. The number of waves in a SET (3-7 waves per set) as well as the length of the intervals between two sets are, within a short space of time, reasonably constant, but over a longer period (several hours or days) they can be strongly variable. SHAPE The surfboard's shape. SHAPING Making the final shape out of the BLANK by sawing, planing and filing/sanding. SHAPER The person who makes the surfboard. SHORE BREAK A wave that breaks directly on the shore and which brings with it a certain risk. When entering and leaving high SHORE BREAK waves, you will need to be very alert, need perfect timing, as well as

a specific technique for diving through. SHORE BREAK waves are usually encountered on steep shore areas and/or at high tide times. //: BEACH BREAK SHORTBOARD A surfboard up to a length of roughly 2.3 metres. The more experienced you are and the less your body weight, the smaller the boards you can ride. Other aspects to consider in choosing your board are the wave height, their speed and steepness. Opposite //: MINI-MALIBU, LONGBOARD SINGLE-FIN A surfboard with one fin. SNAKING To push in front of someone who has the right of way and take their wave. SOUL-SURFER Someone who avoids competitions and commercialisation. SOUP (French: la MOUSSE) When a wave breaks it creates foam. As the SOUP holds lots of air, there is not enough force to hold up a human body on the surface, but it holds too much water to enable you to breathe. //: WHITE WATER SPIN-OUT Sideways slipping away of the TAIL, caused by flow loss on the FINS, and thus also a loss of sideways force. This happens at very high speeds, creating air bubbles on the fins. Next step: WIPE-OUT. Can be avoided by braking and taking your weight off the tail end. BLOW-OUT High air pressure in a tube. As the waves closes behind you, the air is compressed and 'spat out'. That can cause quite a wind current. SPOT The place where a surfable wave breaks. SPRING SUIT A wet-suit to be worn in warm water. It has short sleeves and often short legs. SPRINGTIDE A stronger tidal movement than usual occuring at phases of the full and new moons. Extreme levels occur at high and low tides. SQUARE-TAIL A relatively broad, straight-cut tail. STEAMER A wet-suit with long arms and legs and thicker neoprene. Worn in colder waters. STICK Jargon for a surfboard. STOKED "High" experienced during a good SURFING SESSION. STRAP SURFING Here the feet are held firmly on the board by straps, so that higher waves can be ridden, higher speeds achieved and you have more control. STRINGER A wooden support running the length of the surfboard. It's already fixed in

BE TRUE TO YOURSELF

the BLANK. SUN BLOCK Protective sun cream that lets through virtually no ultra violet rays to the skin. Imperative in very sunny conditions. It should be impervious to water – most products are only impermeable in the bath, but not in the sea. Gels are better for those with allergies because they don't contain emulsifiers. Recommendation: sun blockers made by Logona (health product retailers). SURF Breaking waves at or near the shoreline. SURF-BOARD The resin encased foam board on which some people can ride in the water. //: SHORTBOARD //: LONG-BOARD SURFARI A surf ride into the "unknown", on a search for good waves. SURF SESSION The time you are in the water surfing. SWALLOW-TAIL A tail with swallow tail form, i.e. with a V-like notch in the middle. Also called "fish". SWITCH-FOOT Skilled surfers who can ride with either the right or left foot forward. T TAIL The back end of the surf-board. TAKE-OFF The beginning of a surfing session, consisting of paddling out, the stand up and the beginning of the ride. THRUSTER Surfboard with three FINS. TIDE Ebb and flood. The interval between one low water and the next. Time taken: usually 12 hours 20 minutes. //: TIDE TABLE Usually available free of charge, these tables give high and low water levels as well as tide heights. They also often give the dates of full, half and new moon phases. TIDE LEVEL The height by which the water level rises or falls. TOP-TURN A curve executed on the upper part of the wave in order to ride down the wave again. TOW-IN-SURF-ING In order to get enough speed up for big waves, the surfer is towed out to the wave by jet-ski. This is usually done when the waves are too high and too fast to be reached by normal paddling. See Jaws or Mavericks. Strap-boards are ideal for this sort of surfing. TRIM 1. Reaching an optimal slide of the surfboard by shifting your weight during paddling or during the actual surf. (Long-TRIM, Di-agonal-TRIM, Fine-TRIM) 2. Sliding characteristics, de-pendent on structural form of the vessel (in this case a surfboard). Here the correlation between speed and steering etc. TUBE Tunnel/green room. TUBE RIDING Surf-ing in the tube formed by the wave. //: TUBE TUCKED-UN-DER-EDGE Ridge on the underside (RAIL). A compromise between sharp anround RAILs. TURTLE A technique for div-ing through waves and used for high, hollow-breaking waves and others, when you paddle out on a small Malibu or longboard. Using this method, your body hangs under-neath the board with your back to the wave. Your hands grip the NOSE or the front end of the board. //: ESKIMO ROLL TWIN-FIN Surfboard with two FINs. W WALL The un-broken wall of the wave. WAX Used to rub on the deck to give a better grip. WET-SUIT Wet-suit made of Neoprene which to a certain extent slows the cooling effect of water on the body. WINDSWELL A swell caused by wind and char-acterised by short, unpredictable choppy waves. WINGER A stepped RAIL – it runs along the tail end and reduces the volume. WIPE-OUT A hard slam, leaving the wave through

an uncontrolled fall, or being "eaten" by the tube. WOODIE A favou-rite car of surfers in the forties and fifties, with timber chassis. See car chapter. Z ZINC PASTE Used as SUN BLOCK. Get it at the chemist, cheaper than in a surf shop. It creates a water-resistant barrier too.

Surfrider
Foundation
E U R O P E

Illustration (right page) by Carsten Raffel for Greenpeace-Maga-zin. www. greenpeace-magazin.de

BE PEACEFUL

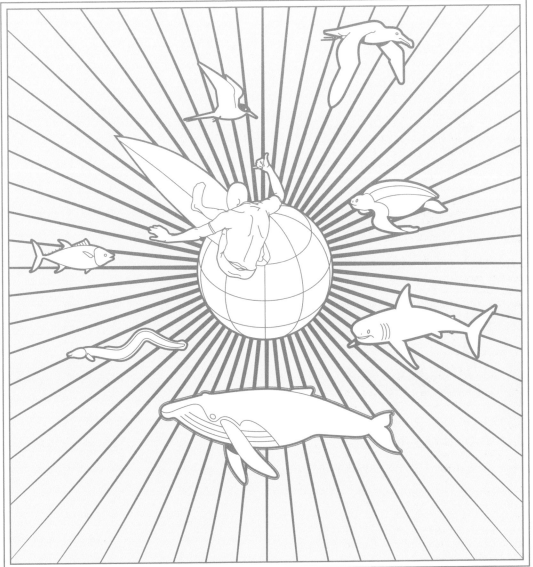

with the sea!

Carsten Raffel a.k.a. Cargo

Jens Meyer a.k.a. Jum

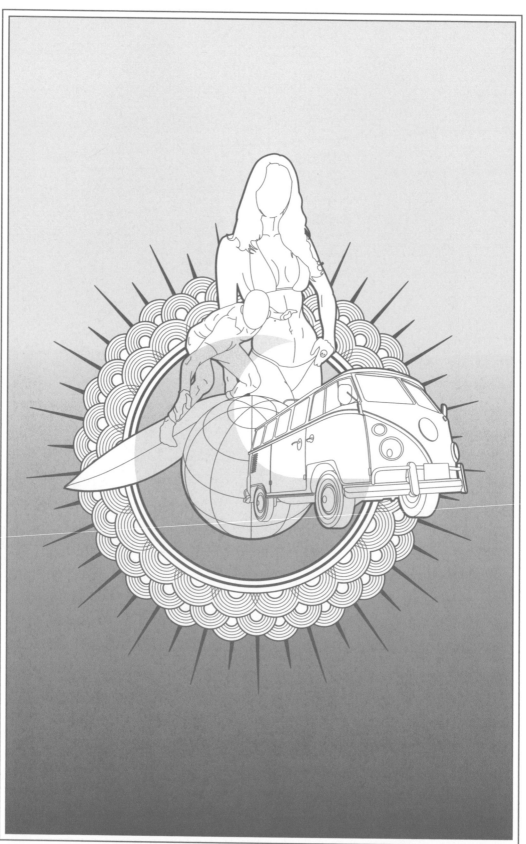